CHARCOAL, SANGUINE CRAYON, AND CHALK

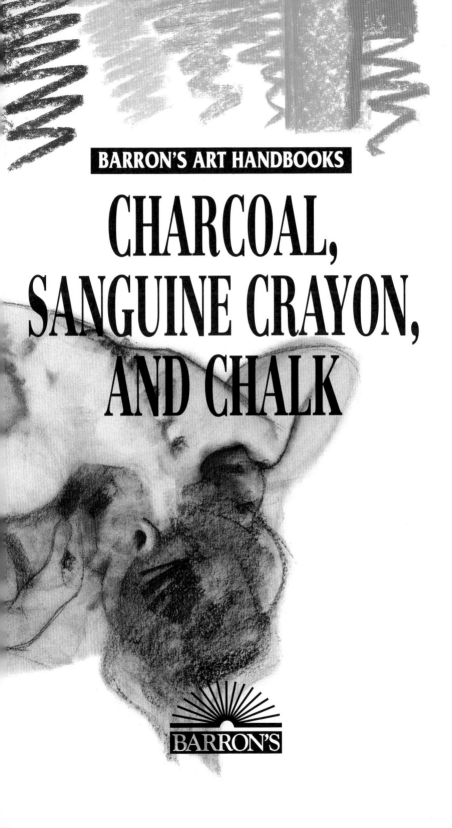

BARRON'S ART HANDBOOKS

CHARCOAL, SANGUINE CRAYON, AND CHALK

BARRON'S

CONTENTS

CONTENTS

SKETCHING IN CHARCOAL

The golden age for charcoal sketches arrived with the legacy of the great artists of the fifteenth century. It also marked the time when drawing became recognized as an artistic discipline in itself. Today charcoal continues as one of the most popular media used by artists for sketching and drawing.

The Paleolithic

Vine charcoal is without a doubt one of the most ancient drawing media known to humankind, along with the ink of squid or of certain mushrooms, or certain pastes made of clays rich in oxide, blood, animal fats, and vegetable resins. There are vestiges from prehistoric times that prove that human beings tried to represent animals, hunting scenes, and so forth, probably for magical purposes. These drawings, made on the rock and ceilings of the caves that served as their shelter, could be realistic or fully abstract, but always with a large dose of stylization. Several of these works have been preserved in caves that were closed off to ensure their protection.

As early as the epoch of Antonello da Messina, it was necessary to draw very well to be able to paint. Antonello da Messina (1430–1479), Portrait of a Young Man. Charcoal on sepia-tinted paper. Graphische Sammlung Albertina (Vienna, Austria).

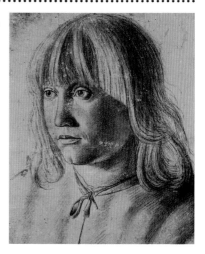

Why Charcoal?

Charcoal is an immediate medium and instrument that requires no elaboration. It is no surprise that many artists, in past centuries, used it for making their sketches once the layout had been established. They are not finished works, because they are made of charcoal and are very fragile and difficult to conserve. On the other hand, it is a quick and inexpensive medium and useful for making large-format studies.

From the Renaissance to Our Time

Beginning with the Renaissance, artists could create a human art, that reflected nearby and identifiable life and surroundings. The major figures were Leonardo da Vinci, Michelangelo, and Raphael, among others. They were followed, in the cinquecento, by a profusion of works created in Florence, Rome, and Venice. Then came the Baroque, with Carracci, Caravaggio, Rubens,

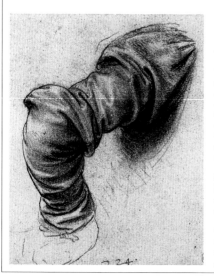

Leonardo da Vinci blended with his fingers, respecting the tonal values and creating a sense of depth. Leonardo da Vinci (1452–1517), Study for St. Peter's Right Arm, 1503. Royal Library, Windsor Castle (Windsor, United Kingdom).

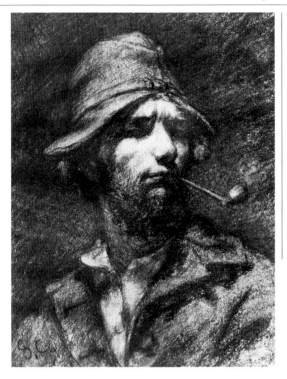

make quick sketches. And more important, this medium is one that can be used to make rapid drawings in a large format, which are very useful for easily analyzing the composition of works that will later be done in full-color oils or acrylics. The ease with which incorrect lines can be erased is doubtless another of the reasons that it is so widely used. But the advantages of charcoal are not limited to the making of drawings on paper. It must be remembered that charcoal is also used for making sketches on the canvas that will be painted with oils, for example.

Gustave Courbet (1819–1877),
Man with Pipe *(self-portrait).*
Charcoal drawing. Wadsworth
Atheneum (Hartford,
Connecticut). As a member
of the Realist School, Courbet
faithfully reproduced what
he saw.

Rembrandt; the eighteenth century, with the Rococo (in France, Great Britain, and Spain); neo-Classicism, Romanticism, Realism, Impressionism . . . until present times. Numerous studies can be found in many museums and art galleries, mainly of the human body, drawn in charcoal as a first step in the creation of a work of art done in a more important medium.

The Artist and Charcoal Today

Charcoal and its derivatives continue to be the most widely used medium by artists to

Ramon Casas (1866–1932),
Portrait of Joaquin Alvarez
Quintero. *Charcoal drawing.*
Museu d'Art Modern (Barcelona,
Spain). An example of charcoal
drawing in the twentieth
century.

DRAWING WITH SANGUINE CRAYON

From the Renaissance until today, sanguine crayon has been frequently used for drawing studies or artistic sketches, since it is a direct medium like charcoal, but more durable. The sanguine will not come off the paper as easily, nor will it smear as much when rubbed.

The Figure

The figure was the main interest of the first artists who introduced the use of sanguine crayon. Most of the time, they must have made large-scale drawings, especially with tempera painting, for covering enormous surfaces such as walls, vaults, and ceilings. The works were almost always related to allegorical and divine worlds. But the representations of the image and likeness of man began to be fully regulated by canons that were very much of the Renaissance.

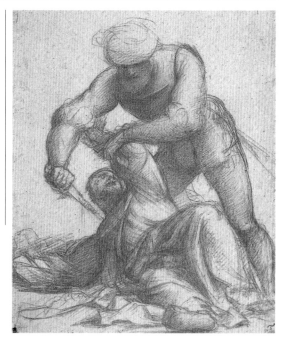

Giovanni Antonio de Pordenone (1483–1539) depicts especially the clothing with oval shapes. The study of proportions and the gesture are perfect, and the interpretation confers a great harmony to the grouping.

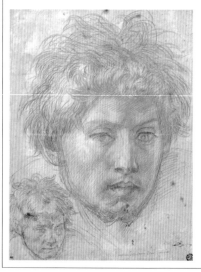

Andrea del Sarto (1486–1531), Head of a Man Seen from the Front. Sanguine crayon on beige paper. Musée du Louvre (Paris, France).

The Studies

Michelangelo is without a doubt one of the most important exponents of the art of drawing. He could perfectly construct the form and its proportions, with modeling that impeccably represented the shading from lights to darks. The whole encompassed not only a profound observation of nature, but also a great knowledge of human anatomy.

Idealization

In the symbolic and allegorical representations, there can exist a certain degree of

idealization of the musculature in the male figure that exaggeratedly emphasizes the prominence of certain muscles in tension. Despite this dramatization, each muscle is in its place, expressing a gesture with a perfect coordination to heighten the mood. All this strongly contrasts with the figures in religious themes made by artists before the Renaissance. From these stylized and simple figures with little expression and dynamism they went to realistic figures with all of the details of the muscles. The faces, before mild, smooth, and not very expressive, went on to dramatically show all kinds of expressions of pain, anger, impotence, and so on, with all of the muscles of the face in full use.

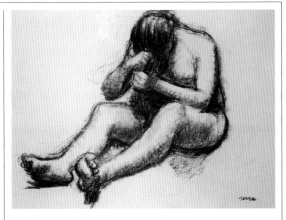

Francesc Serra, drawing in sanguine crayon on cream-colored paper. The drawing was made from a model in the studio. The light from above is emphasized by the direction of the strokes.

Monochromatic Work

Sanguine crayon is associated with a red color, but it also is available in a darker tone or sepia. Work done in sanguine crayon is usually monochromatic. It is made using all the tonal values that can be created with the color that is used and the color of the paper itself, usually light.

Skin Tones

Sanguine crayon is used for figure studies or portraits because of its ease in depicting the skin tones in quick studies, especially when using a paper whose color goes well with them. The paper is a perfect base, adding its color to the tones of the sanguine crayon.

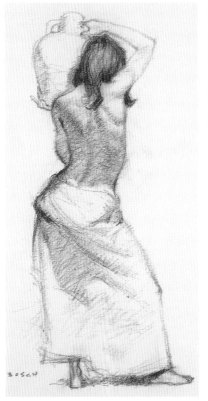

It is not necessary to give the entire sketch the same level of detail. In this work by Bosch, the focus of the artist is centered on the gesture of the back.

Anatomical Studies

Knowledge of human anatomy increased with the scientific discoveries of the Middle Ages. Some doctors, facing the ire and the taboos of a still secretive era, investigated how the human body functioned in autopsies, with scalpel in hand. The most restless artists were able to acquire much more knowledge based on the progress of experimental science than they would have in antiquity. The location of the muscles and how they worked were concepts that were basic to the detailed exercises of observation of the life models they studied.

WHITE CHALK

The first chalk ever used was white. This chalk was first used in mixed techniques, for highlighting, with charcoal and sanguine crayon. Chalk, charcoal, and sanguine crayon are dry media with somewhat different characteristics, but they are perfectly compatible with one another for mixed-media techniques.

A Common Practice

The use of white chalk for highlighting charcoal or sanguine drawings is a common practice. Once it was realized that white chalk and charcoal, or white chalk and sanguine crayon, are media that can be compatible, it became widely used because of its many advantages. It can be erased without very much rubbing, and it can increase the possibilities of creating tonal ranges.

Highlighting

When drawing with charcoal or sanguine crayon, the lightest value is the tone of the white paper. When a paper of a light color is used, the lightest tone of the drawing is still the color

Sebastiano del Piombo (1486–1547), Nude Woman Standing. *Charcoal drawing with white chalk highlights, on blue-tinted paper. Drawing collection, Musée du Louvre (Paris, France).*

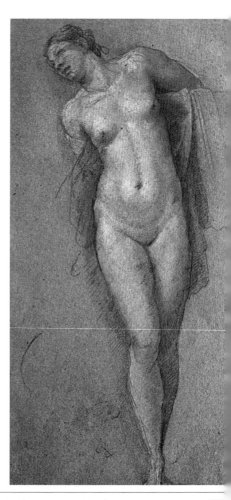

Here is an example of an attempt at a study that promoted the use of different media for mixed techniques. Andrea del Verrochio (1435–1488), Head of a Woman with a Complicated Hairstyle. *Metropolitan Museum (New York, New York).*

of the paper. But from the moment the white chalk is introduced, the system of representing values changes. The white chalk is used for highlighting, that is to say, for creating a greater sense of depth, enriching the work with masterful chiaroscuro.

White Chalk and Charcoal

The white chalk can be mixed with charcoal on white paper, and gray tones that enrich the entire work are created that are impossible to achieve with charcoal alone. When drawing on colored paper, the lightest tone of all is the white of the chalk. But, when mixing the charcoal and the white chalk, a wide range of grays are created that can be used along with the different values of the charcoal on colored paper.

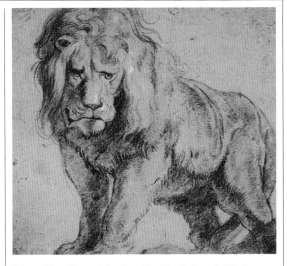

Rubens, Lion. *Charcoal drawing with white chalk, on light beige-sienna colored paper. National Gallery, (Washington, D.C.).*

> **MORE INFORMATION**
> - The First Chalks **p. 12**
> - Sanguine Crayon **p. 18**

Sanguine Crayon, White Chalk, and Skin Tones

When sanguine crayon and white chalk are mixed on the paper, beautiful tones with pink and cream shades are created that are very close to the general coloration of Caucasian skin. They can easily be used to represent a life model.

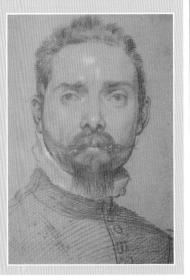

Annibale Carracci (1560–1609), Portrait of a Member of the Mascheroni Family. *Sanguine drawing with white chalk highlights, on paper tinted a light sepia. Graphische Sammlung Albertina (Vienna, Austria).*

The Grays

Using the "grays" created with the different tones of the charcoal and the white of the paper for semitransparence, and the grays created by mixing the charcoal with the white chalk, we can create light and shadows that allow us to easily model any volume. One has the impression that a drawing made with the mixed media of charcoal and white chalk seems to literally come off the paper. This is the most elaborate representation that can be created without the use of color.

White Chalk and Sanguine Crayon

The technique of mixing sanguine crayon and charcoal permits the creation of marvelous chiaroscuros. A tonal range can be achieved with the sanguine crayon alone, another range with the white chalk alone (only on colored paper), and a range of brown and reddish tones when mixing the sanguine crayon and white chalk in different proportions.

THE FIRST CHALKS

The first chalk that was used for drawing was white. It was used in mixed techniques, as highlights for charcoal and sanguine crayon, and was later followed by black chalk. Only much later were chalks of other colors used, and more to add a note of color than to actually create a drawing.

Coloring the Drawing

The usefulness of colored chalk for several centuries was reduced to being a simple aid for lightly coloring a drawing made with another, more conventional medium such as charcoal or silver point. It continued that way until a new formula was arrived at for making sticks of color with much more spectacular results than the chalk, which we know as pastels. At the beginning of the seventeenth century, pastels experienced a great growth in popularity and in themselves became known as a drawing-painting media.

Making Colored Chalk

Artists of those times were like researchers, experimenting to find the most useful medium for making their drawings.

They were always interested in finding new formulas, especially for representing the figure.

They began to make chalks of other colors, because of the necessity of making more complete preliminary studies,

and the immediacy of the dry medium having been proven. To make the colored chalk, pigment is mixed with powdered white chalk and gum arabic, and left to dry in a mold.

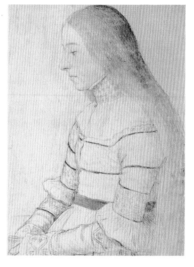

Hans Holbein "the Younger" (1497–1543). Portrait of Ana Meyer. Silver point, charcoal, colored chalk, and light yellow-tinted paper. Öffentliche Kunstsammlung. Kupferstichkabinett (Basel, Switzerland).

François Boucher (1703–1780), Diana Sleeping. Drawing in dark sienna chalk, with white chalk highlights, on beige paper. École des Beaux-Arts (Paris, France).

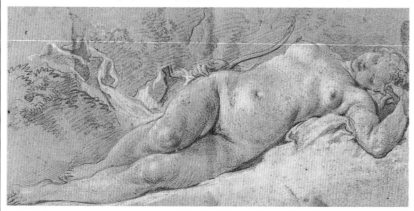

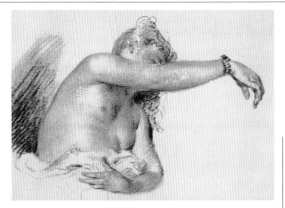

Jean Antoine Watteau (1684–1721). Nude Study. Sanguine crayon and sepia chalk on light beige paper. Drawing collection, Musée du Louvre (Paris, France).

The paste, once it has dried, comes out of the mold in the shape of a bar or stick.

Black Chalk and Gray Chalk

Along with the white chalk, the first colored chalk to be used was black. The composition of chalk, different from that of charcoal, turns it into an especially ideal medium for preliminary studies, because added to its immediacy are better results when blending and rubbing. Starting with the black chalk, gray tones can be created by adding corresponding amounts of white chalk.

Sanguine Crayon and Chalk

One of the first mixed-media techniques combines sanguine crayon with the use of white chalk for highlights and black chalk for blocking in. It is a variation of drawing *á trois crayons* (with three pencils). Later, some other color of chalk would be used to complement the sanguine crayon, such as yellow, for example, to enrich the subtle tonal ranges to create skin color. But colored chalk also would be introduced to color drapery and objects, to produce strong and attractive contrasts with the moderated color (the dominant sanguine) that represented the flesh tones.

A Few More Colors

Besides the black and gray chalks, and the sanguine crayons, ochre and blue were in existence by the end of the seventeenth century. Although pastels (which are soft, unlike the chalks, which are hard) became increasingly important in the eighteenth century, it was not until the end of the nineteenth century that there was a larger selection of chalks or hard pastels.

The Master's Studio

All of this required experimenting with the type and quantity of pigment, the proportion of chalk, and the proportion of the gum that was used as a binder. This process shows the great interest that motivated the artists. The famous studios of the masters where the disciples learned their trade and their art were authentic laboratories. It is important to keep in mind that in those days, most of the artists and studios tried to stay in contact with each other, and that many drawing techniques were collected in teaching and methodology manuals.

Pietro Berretini, called Pietro de Cortona (1596–1669), Study of a Young Woman. Sanguine crayon and black chalk with white chalk highlights. The color of the paper in this case is gray. Graphische Sammlung Albertina (Vienna, Austria).

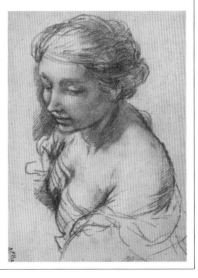

THE MEDIUM

CHARCOAL

In the beginning, charcoal was used in sticks or ground into powder. Today, we can make use of many more articles derived from charcoal, such as charcoal pencils and bars or sticks of artificial compressed charcoal. All of these new products have properties that are very different from the original charcoal and vine charcoal.

The Charcoal Pencil

The charcoal pencil is also known as the *Conté crayon* or *pencil*. The lead, protected by the wood shaft of the pencil, is made of vegetable carbon and binding ingredients. Charcoal pencils are available in various grades of hardness. Unlike vine charcoal (a simple carbonized branch of willow, grapevine, or walnut), the Conté or charcoal pencil is more difficult to blend, lends itself less to correcting, but in exchange offers a much more intense and stable black.

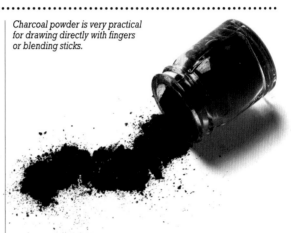

Charcoal powder is very practical for drawing directly with fingers or blending sticks.

Other Derivative Products

The bars of compressed artificial charcoal on the market can be square or cylindrical. Sticks of compressed artificial plaster chalk are also used, sharpened to a point like thick pencil leads.

Bars of artificial compressed charcoal can be found in different grades of hardness.

Sticks of compressed artificial charcoal of the Conté type, whose composition is the same as that of the pencil, are also used. But they have a larger diameter and can be used in holders the same as charcoal and clay sticks.

Brand Names

All of the brands that manufacture products for drawing professionals offer a wide range of bars and sticks of compressed artificial charcoal and charcoal pencils. For each one of these, there exists a series of different grades of hardness. Among the professional brands, the qualities are basically the same. Choices depend mainly on the qualities required of the charcoal, according to the needs of the drawing. It is a good idea to practice with the different sizes and hardnesses of the charcoal, and in general with all products based on charcoal, until their differences are understood. Blending is one of the most important things to try.

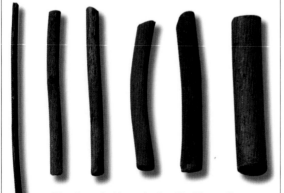

Vine charcoal sticks can be found in different diameters, running from ³⁄₃₂ inch (2 mm) to ¼ inch (2 cm).

1. Bar of black chalk.
2. Bar of compressed artificial charcoal.
3 and 4. Sticks of artificial charcoal and clay,
in different grades of hardness.
5 to 7. Charcoal pencils of different brands and grades of hardness.
8 to 10. Vine charcoal in different sizes and grades of hardness.

The Instrument

Vine charcoal should be chosen based on how regular and cylindrical it is. In the bars and sticks, the usual forms are the square or cylindrical bar, one end of which can be pointed.

Each one of these has its own particular application, not only because of the shape of the bar, but also for its grade of hardness and its composition. The binders, the chalk, the clay, and possible heating convert each of these products into media that have a different ability to adhere to the paper. The same gesture, made with different products, leaves different marks on the paper. One must become familiar with them and use them when they are needed.

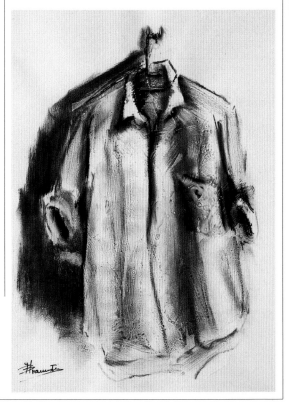

MORE INFORMATION
· Sketching in Charcoal **p. 6**
· White Chalk **p. 10**
· The First Chalks **p. 12**
· The Different Blacks **p. 16**
· Dry Media **p. 26**

M. Braunstein uses vine
charcoal to give volume to
a shirt on a textured paper.

THE DIFFERENT BLACKS

The blacks of bars, sticks, and pencils are very different, and using them as a mixed technique in the same drawing allows us to create some truly rich contrasts. It is a good idea to become familiar with the qualities offered by each one of these products and its use in mixed-media techniques.

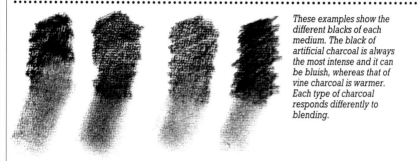

These examples show the different blacks of each medium. The black of artificial charcoal is always the most intense and it can be bluish, whereas that of vine charcoal is warmer. Each type of charcoal responds differently to blending.

Vine Charcoal

The mark left by the charcoal on the paper has different variations, according to the origin of the burnt stick, whether willow, grapevine, or walnut, and also according to its hardness. Vine charcoal produces warm blacks. This is even more apparent when the mark or line is blended. When the charcoal is totally blended, only a very light and delicate mark is left, of a light tone bordering on sepia.

Siberian Charcoal and Charcoal Pencil

Vine or vegetable charcoal is, however, the most volatile dry medium that exists. Even in antiquity, they attempted to give it some consistency by adding animal fats, soot, and

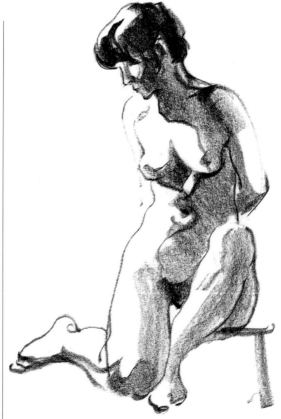

MORE INFORMATION

- Sketching in Charcoal **p. 6**
- White Chalk **p. 10**
- The First Chalks **p. 12**
- Charcoal **p. 14**
- Dry Media **p. 26**

A figure study that shows how to use vine charcoal to indicate the contrast between the values of light and shadow, and to model the volumes and define the forms.

clay. The ingredients and the processes that are used today are able to create a less volatile product, but at the same time influence the kinds of black that are created.

Compressed artificial charcoal, or Siberian charcoal, produces a very intense black.

The cast is quite bluish. The binders in its composition cause the stroke and the shading to be more difficult to erase, blend, and even rub. For the same reasons, a drawing made with this charcoal is much more durable than one made with vine charcoal.

The charcoal pencil, with characteristics similar to those of Siberian charcoal, also has a harder lead and the ability to make very fine lines since the point does not break or wear out very easily.

The Box

Any well-known brand of drawing supplies will have for sale a special box for charcoal work. In these boxes are charcoal pencils, pressed artificial charcoal bars, and vine charcoal, all of different grades of hardness. They also include one or more blending sticks and a kneaded eraser. It is possible to make any kind of drawing with these materials, and even to use them all on a single work of art.

There is also a personal option. When a box with compartments is put together by the artist, the choice of drawing materials can be more personalized. For example, a cotton rag, cotton swabs, a small natural sponge, a small brush, and perhaps even a fan-shaped brush can all be added. All of these are usually used for blending. Some artists sketch and make studies using two or more media, such as charcoal and sanguine crayon, charcoal and white chalk, and so on. In such a case, the box should contain everything necessary, carefully separated so that one medium does not dirty another one.

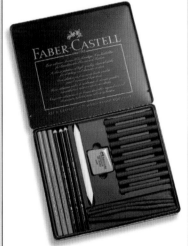

In a brand-name box, there is a studied selection of various products for different uses.

A wood, plastic, or cardboard box is good for keeping a more personal variety, perhaps with more blending sticks or sanguine bars to complement the charcoal.

THE MEDIUM

SANGUINE CRAYON

Sanguine crayon is made of natural pigment and iron oxide. Red iron oxide is the color that is usually associated with sanguine crayon, but there are also bars of other colors, earth tones such as sepia or bistre. The attributes of the bar, the sanguine pencil, or the large stick are different, and will be learned with use.

Bars: Sanguine and Sepia

The sanguine bar is square, about 3/16 inch (5 mm) on each side, narrower than the chalks. It is very hard, especially the bistre, which has been lightly baked to keep it from breaking easily when drawing lines with it. Handling the sanguine crayon is not, therefore, so delicate, and the paper can be colored by pressing lightly on it. This al-

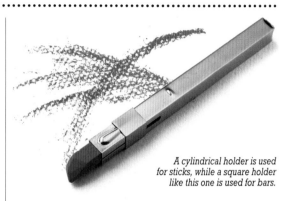

A cylindrical holder is used for sticks, while a square holder like this one is used for bars.

The assortment of colors in pencils is the same as that of the square and round sticks.

The sanguine stick is cylindrical, with a point on one end.

lows lines and colors that are very light but clear.

A drawing made with sanguine crayon is much cleaner and delicate than one made with charcoal. Furthermore, if it is used with a proper colored paper, the possibilities for modeling are endless.

The sepia bar consists of natural pigments, synthetic colors, chalk, and synthetic binder. It comes in two tones, one light and the other darker.

The Sanguine Pencil

The sanguine pencil is also known as a Conté pencil, for the man who introduced a formula that, by adding a bit of clay, a little baking, and a binding substance, produced sticks of different hardness, even somewhat soft. The ability of the sanguine pencil for making lines and hatching makes it ideal for using in combination with the bar form.

The sanguine bar, because of its hardness, is much narrower than the hard chalks and pastels.

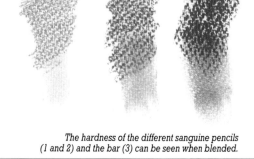

The hardness of the different sanguine pencils (1 and 2) and the bar (3) can be seen when blended.

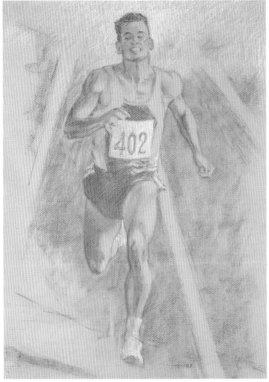

Josep Torres used sanguine crayon to represent the movement of an athlete in a race.

The Large Sticks

There are also sanguine sticks that are $^3/_{16}$ inch (5 mm) in diameter. They come in the same colors as the bars and pencils. The stick is cylindrical and is pointed on one end. Its hardness and consistency are similar to those of the leads of the sanguine pencils. The stick is often used with a special holder, and it is more versatile than a pencil, because it combines the pencil's ability for drawing lines with that of the bar for coloring because of the thicker lead.

Le Dessin à Trois Crayons

In the eighteenth century, most artists drew using mixed techniques. The most popular, developed by Watteau, was *le dessin à trois crayons,* or drawing with three pencils: charcoal, sanguine, and white chalk. The outlines of the drawing are usually done in charcoal. But the colors and tones of the forms can be created by mixing charcoal alone, sanguine alone, white chalk alone, charcoal and sanguine, charcoal and white chalk, and sanguine and white chalk. Using this mixed technique one can create some lights and darks that express all of the modeling of the forms.

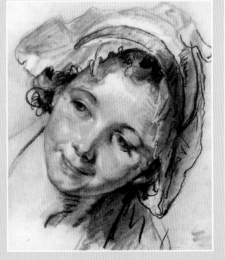

Jean Baptiste Greuze (1725–1805), Head of a Young Girl. *Charcoal pencil, sanguine crayon, and white chalk highlights, on white paper.*

THE SANGUINE COLORS

Unlike the chalks, which today are available in a much wider selection of colors, the sanguine colors cover only the range of iron oxides. Red and gray are the most conventional tones of sanguine, and today, they are available in a complete tonal range.

Oxide and Chalk

The artists of the past, who made their own sanguine bars, depended on the properties of the clay soil from which the pigment was derived. The shade of the "red" varied with the greater or lesser amount of white calcite earth or chalk included in the mix. Thus the red could be very intense and dark, or lighter and somewhat grayish.

With today's manufacturing methods, a common chromatic reference has been established for all sanguine colors. The shade may be a reddish ochre, a true red, or a dark

For each drawing, everything that is going to be used in creating the work is chosen from among the available materials.

red. Since it is possible to find an increasingly large range of colored chalks, several tones of chalk within the sanguine range can also be found. They are used for drawing without the need of using whites.

More or Less Heat

Besides the ingredients that make up the composition of the sanguine bar, another essential factor is the process that is carried out to finish the corresponding tone: the appli-

cation of heat. When it is a little hotter and applied over a shorter time, the bar takes on a darker tone. The hardness or fragility of the sanguine also depends on the time and temperature of the heat.

The small amount of heat that is applied to the sanguine is what gives it a greater hard-

MORE INFORMATION

- Drawing with Sanguine Crayon **p. 8**
- Sanguine Crayon **p. 18**
- Dry Media **p. 26**
- More Tools for Blending and Rubbing **p. 44**
- What to Draw With **p. 52**

The selection of sanguine colors in bars or pencil is limited to those that are known as the earth reds and grays.

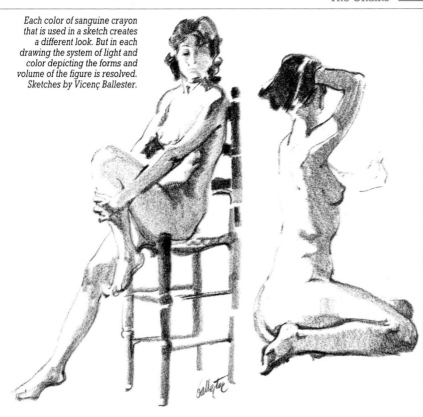

Each color of sanguine crayon that is used in a sketch creates a different look. But in each drawing the system of light and color depicting the forms and volume of the figure is resolved. Sketches by Vicenç Ballester.

ness, and explains why these square bars have a smaller width than that of the chalks.

This heating and the hardness of the sanguine give it characteristics more like those of the hard and dry pastels and chalks.

The Hard Edges

When comparing the characteristics of a sanguine crayon with a chalk bar, it is evident that the edges of the sanguine are harder and more durable than those of the chalk. To prove this, one need only scratch the edge of a bar of chalk with a fingernail and then do the same with a sanguine crayon. The sanguine is harder. Thanks to this durability, a line drawn with a sanguine crayon can be very fine.

Sanguine and White

On an appropriately colored piece of paper, the mixed technique of combing sanguine crayon and highlights in white chalk, in the hands of a great artist, can be used to create incredible effects of depth and volume. The lightest flesh tones are made by the color of the paper and the full range created by working the sanguine with white chalk highlighting.

The different colors of sanguine crayon can be used along with the white in the same artwork to represent flesh tones. The black chalk is used mainly for outlining and blocking in.

THE CHALKS

Colored chalk and schoolchildren's chalk are a direct drawing medium, with which very large surfaces can be colored with great ease. Professional-grade chalks adhere much better to paper than do the chalks used in school. The latter are used mainly for making quick layouts.

The Colors of Chalk

Chalk is a calciferous rock with organic origins, white or gray in color. Reduced to powder and cleaned of impurities, it is kneaded with water and a binder, usually gum arabic. Then it is left to dry in its mold, where it becomes a bar of white chalk. The fundamental thing about chalk is that it cannot be heated. When we wish to make a colored chalk, an amount of pigment is added to the wet paste before it is put into the mold and allowed to dry. Black chalk, for example, is composed of mainly charcoal, soot, and binder. The grays have natural pigments, synthetic colorants, and chalk.

The Shape

Bars of chalk have a square section of ¼ to ⅜ inch (7 to 10 mm) per side, as a minimum, and are about 2¾ or 3 inches (7 or 8 cm) long. Very fine lines may be drawn with the edges of the square shape.

Pigments are used for coloring chalk.

Boxes with several colors are easily found, but if chalks are purchased separately it is a good idea to find a cardboard box with compartments to ensure that the materials are well protected.

MORE INFORMATION

- White Chalk **p. 10**
- The First Chalks **p. 12**
- Chalk or Hard Pastels **p. 24**
- Dry Media **p. 26**
- Colored Paper **p. 34**

It is common to find a wide range of gray-colored chalks.

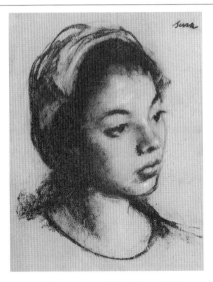

Francesc Serra uses two chalks, blue and white, for the highlights in this Study of a Head, *on colored paper.*

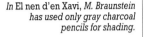

In El nen d'en Xavi, *M. Braunstein has used only gray charcoal pencils for shading.*

And, with a whole flat side on the paper, or a corner on edge, wide lines can be created.

The Consistency

Chalk is more durable than vine charcoal, although less so than sanguine crayon. But once a line is drawn, its consistency is also different. When experimenting with chalk, for example, breaking up a small piece with the fingers, one can see that the powder is nearly as slippery as talc. This indicates that, whether with fingers or a blending stick, it will be very easy to spread on the paper.

The Selection

When chalks were coming into use, few colors were being made. Nowadays, although the selection of colors does not match that of soft pastels, one can still speak of there being a wide range. Some of the specialized brands offer up to 100 colors. There are boxes available with 12, 24, and 48 colors. It is best to have the large box to be able to draw in full color, since that way it will not be necessary to mix the chalks as much, to obtain cleaner and more attractive results.

Difficult to Conserve

Chalk is a difficult medium to conserve, and it is used mainly for layouts and sketches. It is very easy to inadvertently erase an area of the drawing by simply brushing it. And if a fixative is used, the result leaves much to be desired, since the colors are darkened and lose their luminosity.

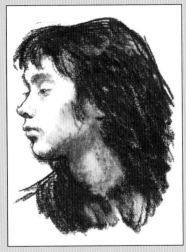

Francesc Serra, Female Head Seen in Profile, *created with blue chalk.*

CHALK OR HARD PASTELS

Nowadays not much distinction is made between chalk and hard pastels. What is more, some brands refer to chalk as bars of dry pastel. Chalk and dry pastels are therefore equivalent and do not offer the variety of vibrant colors found in soft pastels, which are made of pure pigment.

Is Chalk a Pastel?

Powdered earths and pigments mixed with water and binding substances, such as gum arabic or resin, make up the composition of pastels. The lower the amount of binding substance, and depending on its properties, the softer the pastels will be. Therefore, one can consider them to be almost pure pigments.

The so-called dry pigments can have different degrees of hardness. Nowadays, chalks are associated with the hardest pastels on the market.

On the other hand, the amount of white chalk contained in the modern bars of chalk makes it possible to produce a wide variety of tonal ranges.

In the *Dessin à Trois Crayons* Style

When beginning to work with chalk, it is very useful to begin with few colors.

Nowadays chalk is considered a dry pastel, of the hardest variety. Some brands offer a variety of up to one hundred colors, although it is never as wide a selection as that of soft pastels.

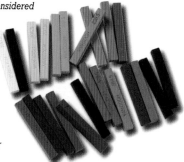

The effect of the color is clearly visible.

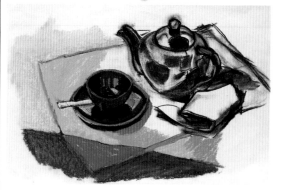

The simplest sketch is the one done with a single color on a small piece of paper. All preliminary studies are important to ensure the results of an oil painting.

Sketches Have Little Color

For most of the sketches that are not considered to be the final product, the only purpose of coloring with chalks is to represent the volume of the forms. In those quick sketches, the work done with chalk consists of simple areas of color here and there, attempting an impression that is clean and immediate.

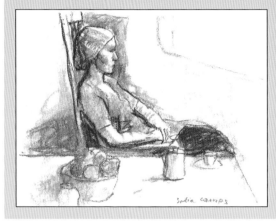

The most elaborate sketches with dry media force the artist to prepare the study of the areas of color. Figure study by Badía Camps. The artist has used chalks of different colors (warm gray, black, sienna, blue, violet, ochre), but barely a few strokes.

This way the artist can go easily from a work with charcoal, sanguine crayon, and white chalk to another in which sienna colored chalk, and black and white sanguine crayon are used.

The shading systems for light and shadow are very similar. In fact, the range of earth tones is widened thanks to light sienna, which is more yellowish than the sanguine color. With these few colors, it is easy to begin to explore chalk as a drawing-painting medium.

A Burst of Color

Unlike charcoal and sanguine crayon, a drawing can be executed with chalk in brilliant and showy colors. The ease with which the color can be applied to the paper, and the effect that can be created, makes chalk an ideal medium for working on sketches and preliminary studies (for blocking in, composition, distribution of areas of color, and so on) of oil paintings, for example.

Color Balance

Colored chalk is a useful and quick medium to use for seeing how color blocks would look in a composition with little effort. This type of color sketch or study, which can be done in the same size format as the final work, reveals any disproportion of the areas of color and allows for the appropriate corrections before the permanent drawing begins. This practice is customary as a preliminary study for oils and acrylics.

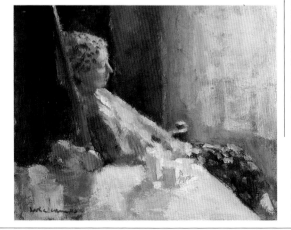

The sketch by Badía Camps takes the form of an oil painting on a canvas board of small dimensions, 9 × 6 inches (22 × 16 cm), the same as the drawn sketch.

DRY MEDIA

Charcoal, sanguine crayon, and chalk are dry media. The most important characteristic of dry media is their volatility, because they can be crushed into powder. It is interesting to work with each one of these media and to compare the results. The differences are obvious and very useful for working with mixed techniques.

Charcoal is fragile and breaks easily.

The loose powder that has not adhered can easily be blown away.

Charcoal Is Very Fragile

Vine charcoal is a very fragile tool, which becomes obvious when it is used, and it must be handled with care. If too much pressure is applied to it, the little stick breaks easily. In fact, it ends up shattered. With practice, one learns to press on it until the point sheds very fine powder without breaking the stick.

No Moisture

Dry media that have not been manipulated, that is, that are not derived from others, contain no moisture. Vine charcoal is the result of burning that is interrupted when the little stick reaches a point where it still maintains its shape, whereas in a total calcination only ashes would be left. Sanguine crayon and chalk are made from their respective pastes. These classic bars are not only left to dry, but are also subject to a brief baking process that eliminates the water completely.

When the finger is rubbed over the crushed charcoal, it is easy to leave a mark on the paper.

Charcoal, sanguine crayon, and chalk are three media, all of them dry, that represent different adhesive abilities, and therefore perform differently when blending (1) and rubbing (2).

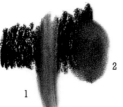

Charcoal marks are almost completely eliminated by wiping with a clean rag.

Chalk Crumbles

Chalk is less fragile than charcoal, but less durable than sanguine crayon. It is a medium that turns into powder very easily by the simple pressure on the paper, or by scraping the chalk with a fingernail, for example. When drawing, you will notice that the chalk powder adheres less than that of the sanguine crayon, but more than charcoal.

Sanguine Crayons Are Durable

Sanguine or sepia bars are durable materials. They do not break easily like charcoal or chalk, especially if the work is done with a piece that is broken in half to make both pieces more durable. When the bar is pressed on the paper, it is the powder that comes off and adheres to the paper that makes the lines.

The durability of sanguine crayon is greater than that of chalk, with charcoal being the most fragile medium.

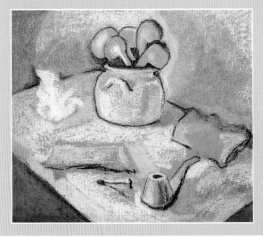

Just Powder and Adhesion

The common characteristic of all these media that do not contain any water—the charcoal, sanguine crayon, and chalk—is that they are dry media, obviously. The quality of the line and its preservation on paper will depend on the adhesion of the powder. Charcoal will come off the paper very easily, the sanguine crayon is, of the three, the one that stays on best, and chalk has a medium adhesive quality.

Keeping in mind the differences, these three media—charcoal, sanguine crayon, and colored chalk—can be used together in any drawing, with artistic results. M. Braunstein created a preliminary sketch for the oil painting titled The Pipe Corner.

THE PAPER

The base par excellence for dry media is paper. Many kinds of papers can be used, but they all share the characteristics that allow the media to adhere. The surface should have enough texture to allow the powder particles that come off from the rubbing of the charcoal, the sanguine crayon, or the chalk when drawing, to adhere to the paper.

Presentation

The paper can be purchased in spiral sketchbooks (wire bound) or in pads (sheets bound with glue on one side), in packs (several small individual sheets in envelopes), and in large sheets sold individually.

White Paper

White or almost white paper allows the charcoal, sanguine

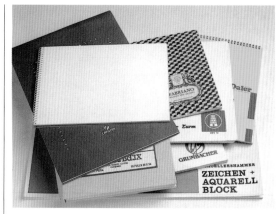

A wide variety of papers can be used for drawing with charcoal, sanguine crayon, or chalk.

crayon, or colored chalk to appear semitransparent when drawing with very light pressure, leaving a faint trace. Very immediate tonal shapes are possible on white paper.

For the beginner, the sketchbooks bound with wire or simply glued are very practical.

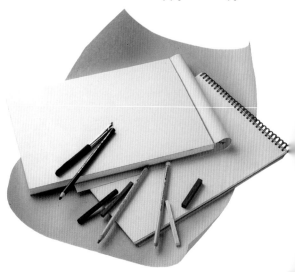

Several white papers are available especially for drawing with charcoal, sanguine crayon, and chalk. Other white papers, appropriate for other media, are also useful for dry media as long as they do not have a satin surface.

Special Papers

Among white papers are some that are special for dry media and that give good results. It is a good idea to become familiar with the various brands and types of papers, because there could be differences in their grain, weight, and the shade of white (such as true white, bluish white, ivory white, and grayish white).

Papers for Other Media

There are white papers ideal for use with media that require water, such as watercolors, that are also good for charcoal, sanguine crayon, or chalk. There are also special papers for graphite, colored pencils, ink, or markers that can have good results with dry media.

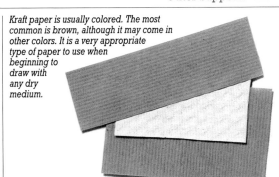

Kraft paper is usually colored. The most common is brown, although it may come in other colors. It is a very appropriate type of paper to use when beginning to draw with any dry medium.

Kraft Paper

Although it depends on the country, in general kraft paper is never white; it is typically brown. On a dark paper like this, the drawings are usually done with charcoal or with colored chalk to achieve good contrast.

Kraft paper is used mainly by the beginner who wants to learn to draw with charcoal. It is a very inexpensive paper, and the beginner feels more comfortable drawing on it without fear of ruining the paper.

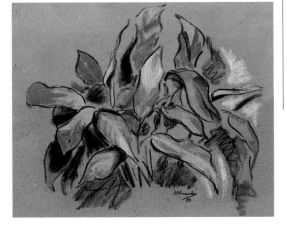

Drawings done on kraft paper allow the beginner to become comfortable with the hand motions used for drawing and coloring.

Recycled Paper

Most recycled paper is good for drawing with charcoal, sanguine crayon, or chalk. The surface is normally coarse, whether it is a rough piece or a fine recycled paper, which can even be used for writing. Therefore, it is a type of paper that allows the adhesion of dry media. The color of recycled paper, dark white or gray, is without a doubt a characteristic that the artist should learn to use.

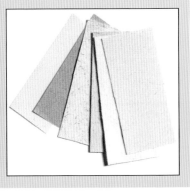

Recycled paper, off-white or even gray, is a good paper to use for drawing with charcoal, sanguine crayon, or chalk.

OTHER SUPPORTS

Although the most common support for charcoal, sanguine crayon, or
chalk is paper, cardboard, wood, fabric, and other supports can be
used. Each of these materials and the characteristics of its surface are
reflected in the results of drawing on it with dry media.

Cardboard

Whether in flat form or corrugated, cardboard is a useful support for any dry medium. Most cardboard is recycled, and unless it is covered with satin paper, provides a very good surface. Corrugated cardboard is useful for creating drawings in which the effects of the texture can produce spectacular results.

MORE INFORMATION

- The Paper **p. 28**
- Characteristics of Paper **p. 32**
- Colored Paper **p. 34**
- The Need for a Board **p. 36**

Wood

Particle board, chipboard, or a sheet of wood, as long as they have not been varnished, can be good supports for drawing with charcoal, sanguine crayon, or chalk. Each one of these supports presents a characteristic surface. Particle board, the result of pressing and gluing small particles of wood, has quite a smooth surface, and has an appropriate texture for the adhesion of any dry medium.

The grain of the wood with its knots can add texture to the results of drawings done with charcoal, sanguine crayon, or chalk.

Fabric

Any fabric that has been primed for painting with oils can be used for drawing with charcoal, sanguine crayon, or chalk. As with paper, fabric can be of a heavy, medium, or fine grain.

Fabrics that are ready and primed for painting with oils are also a good support for dry media. The ones with heavy and medium grains provide good adhesion.

Cardboard usually has the characteristic color of recycled paper. The heavier ones do not need to be attached to a wood back because they are already hard enough.

Corrugated cardboard is an interesting base that is worth trying for the suggestive effects that the wavy texture creates on the drawing.

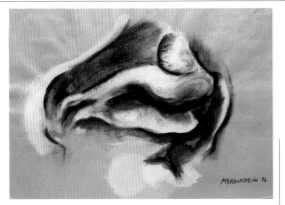

*M. Braunstein, Study of Lips.
The thickness of wrapping
paper is enhanced with
priming and texturing. Above
all, it increases the adhesive
ability of dry media.*

Texture and Rhythm

A surface that has been especially textured with a product that can be applied in thick layers can be an important element. It allows the creation of a rhythm that instills drama in the features and directions of the drawing with the modeling of the forms, and in this way create atmospheres of great artistic quality.

Each type of grain will therefore produce a different type of texture. With a heavy grain, mixing with the eye can be suggestive and provide a strong personality to the drawing. On the other hand, a drawing on a fine-grained fabric does not provide this type of optical mixtures.

when they are dry, can provide an ideal surface because of their capability of maintaining the adhesion of the shading or coloring done with dry media.

Other Supports

It is possible to prepare a special surface using heavy paper, cardboard, wood, or fabric. Numerous products are good for applying texture to the surface, such as acrylic modeling paste, latex with an adequate amount of thickener, and so on. These products can be applied in thick layers, and

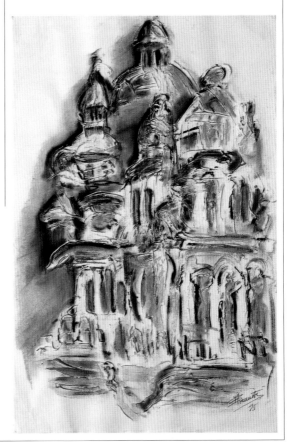

*Paper, board, and simple or
corrugated cardboard can
be prepared with a special
modeling paste (acrylic
modeling paste or a paste with
a latex base), which hardens on
drying. It offers a good surface
that is adherent for any dry
medium. M. Braunstein, in Le
Sacré Coeur, models a base for
creating a rhythm to enhance
the optical contrasts and to
create an authentic work of art.*

CHARACTERISTICS OF PAPER

One of the most important characteristics of a paper for drawing with charcoal, sanguine crayon, or chalk is that of keeping the powder of the medium adhered to its surface. It is not advisable to use a paper that saturates easily because it is not possible to go over the work repeatedly.

Adhesive Qualities

Only the papers that do not have satiny surfaces are good for drawing with charcoal, sanguine crayon, chalk, and pastels. On a surface that is smooth and slippery, like that of satin paper, the dry medium does not stay adhered no matter how hard the bar is pressed. As far as papers with nonsatiny surfaces, not all have the same adhesive ability with a dry medium. Therefore, it is important to experiment with each type of paper.

A satiny surface repels any dry medium.

Saturation

Saturation is associated with the adhesive ability of the surface. When the artist continually works on a shaded or colored area, some papers get saturated more easily than others. That is, no matter how much the artist works the medium, it is not possible to get a darker color, and in addition, the powder that has not adhered comes off easily.

MORE INFORMATION
- The Paper **p. 28**
- Colored Paper **p. 34**

The Problem of Saturation

The difficulty of working with a paper that is not appropriate for a dry medium is that it cannot be corrected, or if so only very little, because the saturation is almost immediate. But with an appropriate paper, even though the saturation does not occur as fast, it is

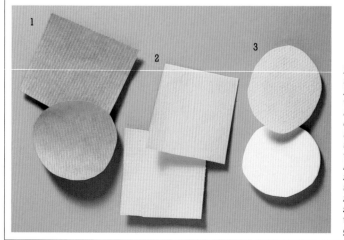

In general each type of paper has two faces with different adherence capabilities for the powder of the dry medium: wrapping paper has one satiny face (1); the textured lines (2) retain more, and so do the papers with a heavier grain (3).

A paper is ruined when the artist overworks one area when erasing or rubbing. The surface becomes unattractive and the adhesive ability is reduced.

The Texture

When the surface of the paper is not smooth (which promotes the wear of the stick or point of a dry medium), the texture that appears with each stroke reveals a grain that can be more or less uniform. One can talk about the pattern of the grain and even whether it is heavy, medium, or fine. Each regular or irregular mark has a different texture effect when it is covered with the charcoal, sanguine crayon, or chalk.

a good idea to draw or color with a firm hand because it is not advisable to correct or to have to work too much on a particular area with a dry medium.

Texture and the Optical Effect

The texture of the paper's surface, after the dry medium has been applied, reveals a specific optical effect. This occurs because the grain of the paper that is colored (the most outstanding ones) and the ones that are not colored (those that are lower) create a mixture that is perceived by the eye at an appropriate distance.

When shading the surfaces of different papers, cardboard, and fabric, very different and interesting textures are created that can be used to give a drawing a dramatic or special touch.

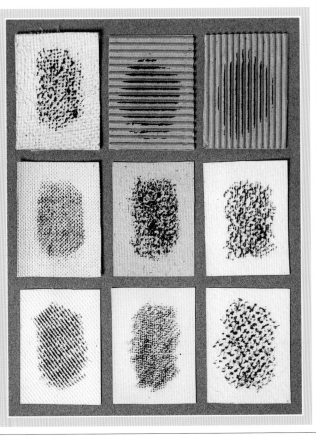

COLORED PAPER

It is common practice to draw with any dry medium on colored paper.
There is a great variety of color choices among the special papers used
for this type of medium. But the chosen colored paper must provide
good contrast with the color of the medium that is used.

Many Colored Papers

A dry medium such as pastels, which come in a wide variety of colors, requires an enormous selection of colored papers. Therefore, when drawing with charcoal, sanguine crayon, or colored chalk, it is possible to always find the appropriate paper among the selection of special papers for pastels.

With the experience acquired from working with these papers, the artist learns to recognize the slight color nuances of the different brands of special papers, because each one presents its own color variety.

Choosing the Color

With so many different colors available, how do we know which one to choose to begin drawing? If you are working with sanguine crayon or chalk, the color of the paper will depend on the colors of the subject matter. However, if you are using charcoal, you can be much more creative with the selection.

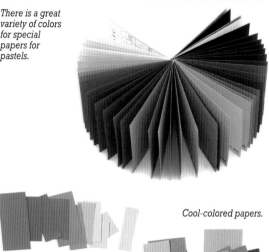

There is a great variety of colors for special papers for pastels.

Cool-colored papers.

Warm-colored papers.

Neutral-colored papers.

In addition to white paper, which comes in different shades, are colored papers.

Color Theory

Color theory is applied when choosing the color of the paper for drawing. The idea could be to create color harmony, but contrast can also be the goal. Chromatic drawings (in black and white) or monochromatic (with different tones of the same color) are the

simplest scenarios with which to practice the effects of harmony or contrast.

Harmonious Color

The most common color ranges are warm, cool, and neutral. To select a colored paper that goes well with these ranges, it must belong to the same range. Therefore, a warm-colored paper will be in harmony with the warm range, and a cool one with the cool range, and a neutral one with the neutral.

Contrasting Color

A colored paper can be chosen to contrast with the color range used for the drawing. This way, the contrast can be

Charcoal and white chalk stand out on a clear, reddish ochre color.

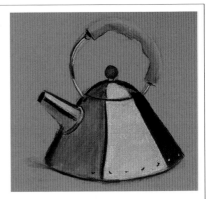

created through tone (for example, a dark-colored paper that is warm for a warm range), or it can be warm-cold (a cool-colored paper that contrasts with the warm range of the drawing, or vice versa). When drawing with charcoal the contrast is guaranteed as long as

the color of the paper that is used allows the black to be clearly visible. Papers of light, cool colors and tones are the most enhancing for charcoal.

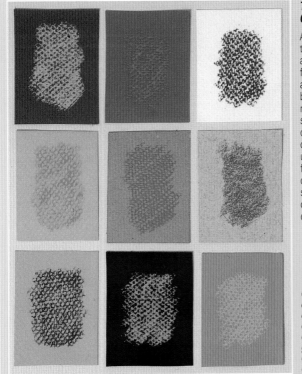

The Most Typical Contrast

A more delicate contrast is created by using a neutral-colored paper for drawing with either a warm or cool range, because it creates harmony. Any brand of special paper for pastels offers a variety of neutral colors, which can be used as a neutral base for most of the drawings done with a dry medium, such as sanguine crayon or chalk. Compare the different effects.

On a colored paper, different optical effects can be created, depending on the characteristics of the grain, the color of the chalk, and the amount of color that is applied.

THE NEED FOR A BOARD

Whenever the base on which the drawing is done with a dry medium is not hard, like paper, it must be attached to a board. The board must have large enough dimensions and an adequate surface, and must be properly attached so the work does not move when drawing with vigorous strokes.

The Size of the Board

The dimensions of the board usually exceed those of the paper by a few inches, between 1¼ and 2 inches (3–5 cm) per side. This part of the board that has no paper allows the artist to hold it without fear of smearing the drawing with the hands dirtied with charcoal, sanguine crayon, or chalk.

The Surface of the Board

The board should have a smooth surface so when the artist draws, shades, or colors on the paper, only the characteristic texture of the paper's surface is picked up.

How to Hold the Paper

The paper should be securely attached to the board. On the one hand, wrinkling the

The board must be slightly larger than the paper. To attach the paper to the board, clips, thumbtacks, or masking tape can be used.

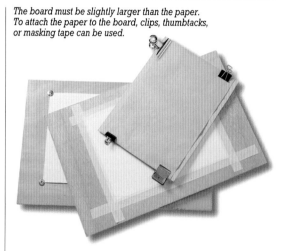

paper should be avoided when shading or coloring vigorously, which can happen if the paper is not heavy enough. On the other hand, a heavy paper that is not properly attached can easily move when placed on the board. To avoid this, four or more clips or thumbtacks can be used, although the latter require piercing the paper.

MORE INFORMATION
- The Paper **p. 28**

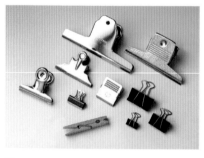

There are some types of clips that because of their size or design can be more practical than others.

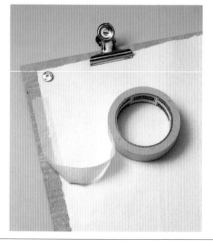

Masking tape also allows blocking off the edges of the drawing. The ideal masking tape should not damage the surface of the paper when it is removed after the work is completed.

A Surface for Creating Texture

If the artist wishes to introduce some special textural effects in the drawing, a surface with texture should be chosen (from the board or from any other element that can be inserted between the board and the paper) as backing, whether the paper is smooth or grainy. A board that is not smooth transfers its texture to any lightweight paper that is attached to it. However, with a very heavy paper that has a lot of body, there is no texture transfer from the board.

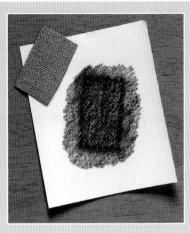

A piece of fabric with a large and irregular weave, placed between the board and the paper, adds special texture to the paper when the drawing is done with compressed charcoal.

The Borders of the Drawing

Another way to attach the paper to the board that keeps the borders of the drawing very clean and sharp is to use masking tape, the kind painters use. This protection makes it easy to erase the surface of the outer border of the paper that may have become dirty during the process.

The most practical support for drawing with charcoal, sanguine crayon, or chalk in the studio is to place the board on an easel.

How to Hold the Board

The board itself must be kept firmly secured while drawing. In the studio, it is practical to have an easel. This way the work is held secure, because one hand holds the easel, and the other is free for drawing. Without an easel, the work has to be held, standing or sitting down, using one hand to hold the top while the bottom rests on the lap, if drawing in a seated position, or on the abdomen, if standing.

A small tabletop easel can be useful for holding the work, and is also easy to carry. In any case, whether the artist chooses to work in a standing or seated position, or with or without an easel, the board has to be held firmly.

PENCILS AND LEAD HOLDERS

The pencil or a holder with thick leads are both drawing instruments. They are
used differently from bars because only the portion of the lead that is exposed
can be used for drawing. Their care and maintenance are also different.

Sharpening

As the exposed portion of
the charcoal, sanguine crayon,
and chalk pencil wears out, it
must be sharpened using a
mechanical sharpener (the
larger is used for a thick lead
or stick), or by hand with a
craft knife.

The lead can also be sharp-
ened, whether it is a regular
pencil or the thick lead in a
holder, using very fine-grain
emery paper. The end of the
pencil or the thick lead in the
holder is rubbed softly and ro-
tated until it acquires the best
possible conical shape.

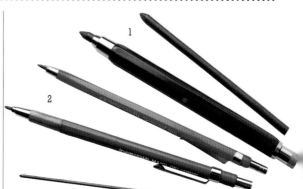

*The sticks can be used with a holder of the
required size (1). This illustration compares the thicker points
with the thinner graphite leads (2).*

A Long or Short Point?

A short point wears out very
quickly, and a point that is too
long breaks off easily if pressed
too hard on the paper. Many
artists prefer to sharpen the pen-
cils by hand with a craft knife,
because this way they can more
easily control the length of the
point that is exposed.

Practice dictates the most
appropriate length—to not
have to sharpen constantly
while making sure it will be
strong enough.

Transport and Maintenance

A box is the most appropri-
ate way of carrying the pen-

cils, sticks, and so on. To pro-
tect the lead and the pencil
from bumps, it is recommend-
ed that a piece of paper towel
folded in half or even a cotton
rag be used to separate and
protect them.

*White chalk and colored pencils
offer the normal durability of a
hard pastel, to which the artist
should become accustomed.*

*The lead of a charcoal
or Siberian pencil is
protected with a
wooden sheath that
provides strength.*

Sharpeners and craft knives are necessary for sharpening the lead of a charcoal, sanguine crayon, or chalk pencil.

MORE INFORMATION
- The Sanguine Colors **p. 20**
- Bars and Thick Leads **p. 40**
- The Dry Media Are Direct **p. 50**

Good Habits Are Useful

Good working and maintenance habits, even if they do not seem very important, turn out to be useful in time. It is not only a matter of saving money, but of maintaining the materials in good working order for when they are needed.

It is truly annoying to have to sharpen a pencil each time it has to be used because the lead is broken, or to have to clean the sticks because they have traces of other colors, just when the artist is ready to begin drawing.

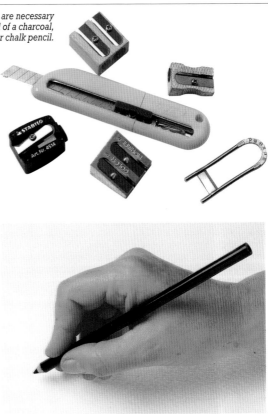

When the charcoal pencil is used for short strokes, it is held close to the lead to keep good control of the motion. This allows us to control the pressure so the lead does not break.

When the sanguine pencil is used for long strokes, it is held farther away from the lead that is in contact with the paper, in a direction that does not break it easily. It must be held sideways, so it is not perpendicular to the surface of the paper. These types of lines require the pencil to be sharpened more often.

Dropping Breaks the Lead

Dropping pencils must be avoided at all costs. If it happens, you will discover that the lead breaks off from inside while the pencil is being sharpened. The purpose of the wood casing is mainly to keep the lead from breaking easily while drawing.

SUPPORTS, MATERIALS, AND TOOLS

BARS AND THICK LEADS

The bars and thick leads that do not require a holder are the medium and the tool at the same time. Therefore, any part of the bar or lead can be used for drawing, shading, or coloring. The point, the edge, or the sides are good for making thin lines, and a piece of the stick or lead can be used for making thick lines.

Making Fine Lines

The small square bars of manufactured compressed charcoal, sanguine crayon, or chalk have several sides. This type of bar can be used to make very thin lines, thanks to the profile at each end. There are eight corners that can be used to make textures. There are twelve edges in all: eight short ones at both ends of the bar, and four edges the length of the bar itself. It is also important to remember that by breaking a bar, the artist can have several pieces with edges of various sizes.

The thick lead or stick is like a pencil, in that it has to be sharpened constantly to make thin lines.

Making Heavy Lines

Thick lines can be created easily by placing the square bar vertically, thereby making a line the width of its square section. The bar can also be broken to make different sizes. The line can be as wide as the length of the piece of bar.

A piece of charcoal or a thick circular lead can produce heavy lines by using the side of a broken piece or the side of the conical point.

A round stick that ends in a point at one end can make fine lines with its sharpened point (1) and with the edge of the flat end (2). Since they are not as practical as the bars for making both fine and heavy lines easily, this type of thick lead is used with a holder.

Compare the lines drawn for making hatching, a line with the point of a thick charcoal that wears down as it moves, and a thin line for outlining.

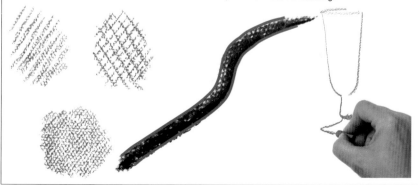

A square bar has twelve edges: eight are short and the remaining four are long.

The Advantages of Square Bars

A square bar can be used for making very thin lines with each of the points without having to sharpen it constantly as is the case with a pencil. It can also be used for making very heavy lines. A simple movement of the wrist makes it possible to have one option or the other.

A Bar Can Be Pulverized

When the artist wants to draw with charcoal, sanguine crayon, or chalk powder, it is easy to pulverize these media by rubbing the bar on a piece of sandpaper. The powder is collected in a small dish, and can be used for drawing directly with a finger coated in powder, or using a brush charged with the particles of charcoal, sanguine crayon, or chalk.

MORE INFORMATION
• Charcoal **p. 14**
• Sanguine Crayons **p. 18**
• Sanguine Colors **p. 20**
• Pencils and Lead Holders **p. 38**
• The Dry Media Are Direct **p. 50**

The sanding block is made of small pieces of sandpaper attached to a rigid base. The artist rubs the bar over it to make points and sharp edges for drawing lines.

The Craft Knife Is Very Useful

The craft knife is a tool that can be used to sharpen a pencil by hand. It can also be handy for scraping the powder off a stick of charcoal, sanguine crayon, or chalk.

The bar, held firmly, is positioned in such way that the end rests on the paper. Then the craft knife is used to scrape one of the sides gently with soft, repeated motions. The craft knife should not cut into the surface of the bar, so it should be held carefully to avoid this. The collected powder is stored in a jar or dish with a wide mouth that can be closed tightly with a lid. This will allow the artist to retrieve as much powder as needed each time and to store it for future projects.

The craft knife is useful for making charcoal, sanguine crayon, or chalk powder easily, by scraping the side or an edge of the bar very gently.

BLENDING STICKS

One of the most outstanding characteristics of any dry medium is that it can be blended. In addition to the hands and fingers, a series of tools is available for this purpose, such as the blending sticks. They are round, they usually have a point on each end, and they are available in different sizes.

What Are They Made Of?

The blending sticks that are sold in stores are made of compressed, absorbent papers, that are rolled and glued together to give them a compact shape with points on each end. The thinnest and smallest blending sticks usually have a single pointed end.

Blending sticks are available in several sizes.

The Purpose of the Blending Stick

A blending stick can be used either for spreading the powder of charcoal, sanguine crayon, or chalk or other dry media adhered to the paper, or for removing it. It is a tool that is used to lessen the contrast of the line drawing, or of the tone of a shaded or colored area. The function of the blending stick, besides removing some of the powder, is fusing the particles with one another on the paper.

If a blending stick is not at hand, it is easy to make one quickly in the studio, using blotter paper.

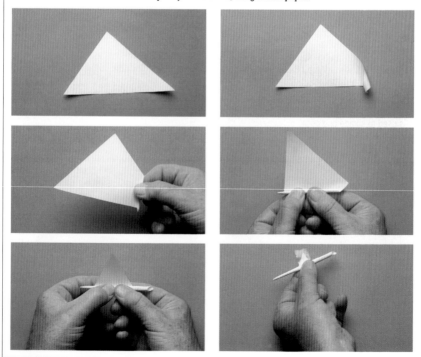

The Parts That Are Used

The areas of the blending sticks that are used are the point and the sides of the cone as the stick is rotated between the fingers, causing every part of the point to make contact with the paper. When one end becomes saturated with powder, the other end of the stick is used.

The Artist Can Make a Blending Stick

Making a blending stick is easy. You must have an appropriate paper that is thick, soft, and absorbent, such as blotting paper. Cut a triangular piece and roll it carefully, so the paper is wrapped very tightly and a point is created. Keep the blending stick rolled up tightly, so it does not become unwrapped, by securing the outer edge of the rolled paper with a piece of tape.

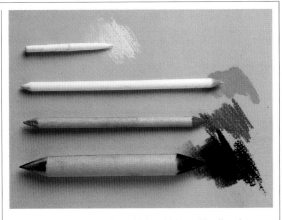

When the artist uses a blending stick for rubbing or blending, the points become saturated with the medium used. It is a good idea to have several blending sticks so work done in sanguine crayons does not get smeared with the charcoal from a stick used for another project.

Many Sizes

There are many sizes of blending sticks commercially available, from very thick to very thin. One particular size can be more appropriate than another, depending on the dimensions of the area that is to be worked. It is a good idea to have several sizes, so the appropriate one is available each time a drawing is begun.

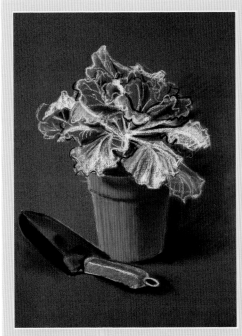

Fingers and Hands

The effects of using a blending stick are different from those made with hands and fingers. The blending stick is dry, whereas the artist's hand always has a certain level of natural moisture, and even oil. Besides, because it is a tool, the blending stick does not offer the same sense of the pressure applied to the paper as the fingers do.

Any part of the hand can be used for blending or rubbing. In this case, it was used for creating the tones and shadows of the pot. The blending stick is useful here just for touching up.

MORE TOOLS FOR BLENDING AND RUBBING

Fingers, hands, and blending sticks are not the only instruments that can be used for blending and rubbing. Many other materials are appropriate for these procedures. Some common ones are cotton rags, brushes, and sponges, each having its own particular mark.

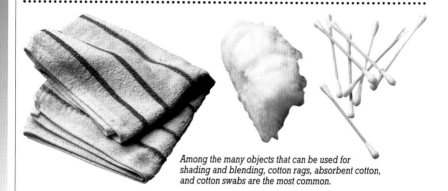

Among the many objects that can be used for shading and blending, cotton rags, absorbent cotton, and cotton swabs are the most common.

A Variety of Objects

Many objects can be used for rubbing or spreading the charcoal, sanguine crayon, or chalk that has been previously applied to the paper. The only requirement they need to fulfill is to not damage the paper.

Sgraffiti, on the other hand, does require a point. This technique, so different from shading or blending, consists of literally scraping a line with that point to let the color of the paper come through, although this can be an aggressive approach for the surface.

Brushes

Any brush, regardless of the type, can be used for shading or blending charcoal, sanguine crayon, or chalk. It can be a brush for oils, gouache, or acrylics. The shape of the hair can be rounded, elongated, or square. The size of the hair is indicated with numbers ranging from 00, the lowest for the finest brush, up to 24 for the thickest hair. A larger type of brush can also be used, with thicker, flat hair arranged in a square shape numbered from 9 to 30. A very special type of brush is in the shape of a fan.

There are also sponge brushes, which are commonly used with water-based paints and in particular for working on silk.

MORE INFORMATION
- Blending Sticks **p. 42**
- Volatility of the Medium **p. 54**
- Blending **p. 66**

Any type of brush can be used to blend or rub charcoal, sanguine crayon, or chalk.

Specific Effects

The effects of blending or rubbing with a brush depend on the characteristics of the bristles and on their shape and size. The softest shading is created with a fan-shaped brush. A taut string can be used to make straight shadings or blends. A cotton swab or a very fine brush are good for working very small areas. A cotton rag is good for larger shading effects. Even a piece of cloth wrapped around a finger can be used for shading areas of that size. Each implement and the way it is used can produce different blending or rubbing results, its area, the amount of powder spread or removed, and the ability of the paper to hold pigment with respect to the lines or coloring that will be applied later.

Notice the results produced by using a cotton cloth (1), a piece of absorbent cotton, (2) or a cotton swab (3) to blend charcoal.

Outstanding fine, linear shading can be created by using a small wooden stick (1) on sanguine, compared with that produced by using blending sticks (2 and 3), no matter how small it may be.

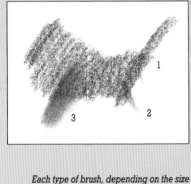

Each type of brush, depending on the size and quality of the bristles, creates different effects when blending blue chalk.

More Tools

A cotton rag, ball, or swab can also be used for blending or rubbing. A piece of commercial or natural sponge can be equally useful. Materials such as esparto grass, raffia, and yarn can also be used to form a ball of the required size. With a little imagination many other types of objects can be used, such as a length of taut string.

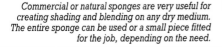

Commercial or natural sponges are very useful for creating shading and blending on any dry medium. The entire sponge can be used or a small piece fitted for the job, depending on the need.

MORE MATERIALS

Erasers are essential for correcting charcoal, sanguine crayon, or chalk.
On the other hand, fixative is required to prevent dry media from being
erased by accident. The layer of fixative should be thin, and spread
evenly over the entire drawing.

The Need for Erasing

Anything that is used for blending and rubbing can be considered correcting material. However, an eraser has to be used for cleaning up and to create white areas. A correction may consist of almost completely erasing a line, a specific portion of a drawing, or part of a shaded or colored area. Whichever the case may be, a commercial eraser or even a homemade one is the implement to use.

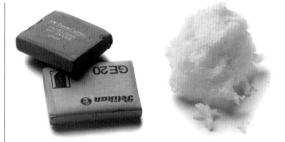

A kneaded eraser is without a doubt the most practical one for dry media, because in addition to collecting most of the residue, it is very soft and does not harm the surface of the paper. A homemade eraser can be made by kneading bread dough with the fingers.

What to Use for Erasing

There are many types of erasers. Kneaded erasers are most commonly used for charcoal, artificial charcoal, sanguine crayon, and chalk. They are very soft and are made of a material that, like its name in- dicates, can be shaped by pressing a piece or the whole thing between the fingers. Because of their composition, the powder of the dry media adheres very easily to the erasers. They are a little tacky to the touch. Other types of erasers, like the plastic ones or the so-called bread erasers, are very useful for creating white spaces in specific areas that are small.

MORE INFORMATION
- The Need for a Board **p. 36**
- Pencils and Lead Holders **p. 38**
- Blending Sticks **p. 42**
- More Tools for Blending and Rubbing **p. 44**
- Temporary Conservation of the Work **p. 92**

There are many types of erasers commercially available. Hard plastic and ink erasers should not be used for dry media, because both types can greatly damage the paper.

More Tools for Blending and Rubbing
More Materials
Caring for the Materials

47

The Shape of the Eraser

Depending on the drawing, the artist may require a narrow and thin piece of eraser, which can be obtained by cutting the rubber eraser with a craft knife. In other cases, however, a piece of a kneaded eraser for charcoal may be cut the same way and shaped according to the area of paper that needs to be erased.

The piece of eraser can be shaped according to the work that needs to be treated by squeezing it between the fingers.

The Homemade Eraser

For a long time, an eraser made of bread kneaded in the required shape was commonly used for wiping the drawing to remove as much of the char-

A piece can be cut off from a kneaded eraser.

coal, sanguine crayon, or chalk that the bread was capable of picking up.

This type of improvised eraser must have a small degree of moisture so as not to smear the drawing. At the same time, it must not be so dry that the powder of the dry medium will not adhere to it. Good results can be had using a bread dough eraser if it is not overused. This eraser dries out very quickly, at which time it should be discarded.

The Need for Conserving

A drawing, even when it has just been finished, can be ruined by simply brushing it. A fixative should be used to prevent the drawing from smearing accidentally. Every dry medium can be preserved with the same type of fixative, the one used for charcoal. Most brands specify that they can be used for sanguine crayons and pastels. The most useful and practical format is a spray. However, it should not be used in excess, to prevent the colors from getting too dark.

The spray can should be shaken before using. After that, the lid can be removed.

Care must be taken to aim the nozzle opening properly over the drawing. The fixative should be used in well-ventilated areas, because this type of liquid contains toxic substances.

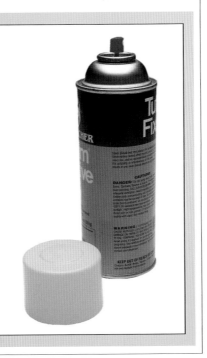

The spray fixative for charcoal can be used for any dry medium such as sanguine crayon, chalk, and pastels.

CARING FOR THE MATERIALS

Between drawing sessions, all the materials should be left in order and protected so they can be ready for the next time. There are just a few practical guidelines, and they are not hard to follow. Each medium should be stored separately after cleaning to prevent them from touching each other. This way they do not become contaminated.

Mixed Techniques

It is very common for an artist to use charcoal and crayons in the same drawing, as well as introducing white or colored chalk. The box or drawer where this drawing material is stored must have specific characteristics so they can be kept clean and stay protected.

The Media Contaminate Each Other

Charcoal, even the commercial type, which sheds less dust, can greatly soil the sanguine crayon and the chalk if they come in contact with each other. Sanguine crayons, even though they lose less powder, also soil anything they touch. The same thing happens with chalk.

All the charcoal should be stored in a separate compartment, away from the sanguine crayons and the chalk. Charcoal can be conveniently stored by itself in any box. Hard plastic boxes the size of cigarette packs are very useful for this purpose.

To store sanguine crayons properly a small box is sufficient, separating the different colors with pieces of paper

The sticks of vine charcoal, sanguine crayon, and chalk—and their leftover pieces—can be stored in small cardboard boxes or in hard plastic boxes like the ones some cigarettes come in, for example. Each medium should be stored separately so the colors do not soil each other. To keep the chalk sticks clean, they must be wiped clean with a cotton rag or a piece of absorbent paper to remove the residue from other colors before they are placed in separate compartments.

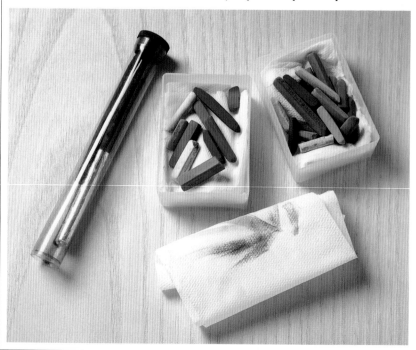

MORE INFORMATION
- Charcoal **p. 14**
- Sanguine Crayon **p. 18**
- The Chalks **p. 22**

Cotton Rags

After working with a dry medium, cotton rags, which are so useful for cleaning your hands as the drawing progresses, as well as for blending and erasing, end up very dirty. They must be shaken out vigorously before they are put away, to get rid of most of the residue powder. Eventually, common sense will dictate the right time to use a fresh cotton rag, seeing that the accumulated residue that is hard to remove becomes a nuisance and begins to affect the results of the drawing.

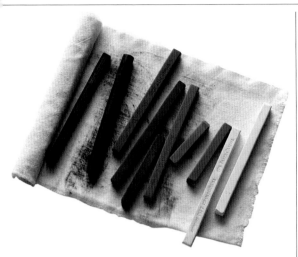

A good habit for working comfortably with charcoal, sanguine crayons, and white chalk is to place the sticks on a cotton rag. This way they are protected and kept clean, and the space between the sticks makes picking them up much easier for the artist.

White chalk should always be clean of residue from other colors or from charcoal before using it.

towel to better protect the small sticks.

Colored chalks must be kept separate from each other, or at least be prevented from being stored too closely together.

The Small Pieces

When new materials are used for drawing, they are perfect and in one piece. But after a single session small leftover pieces of different shapes and sizes begin to gather, as well as fragments of pencil leads broken off at each sharpening.

With patience and a system, an effort should be made to keep everything as organized as possible: the charcoal with the charcoal, the sanguine crayon with the sanguine crayons, and each piece of chalk with its own color.

All these materials, even the smallest pieces, can be used for another drawing.

Getting the Pencils Ready

A good working habit is to sharpen all the pencils that have been used in a drawing and to keep them ready for the next session. There is nothing more annoying than to be inspired and then realize that the materials are not ready to use.

New blending sticks should also be stored separately from the used ones to prevent them from getting dirty.

THE DRY MEDIA ARE DIRECT

Sticks, bars, and pencils are used for drawing, shading, or coloring directly on the paper without the need for agents or added products. The foil sleeve on the thick charcoal stick makes it possible to draw without getting your hands too dirty, and it can be removed as needed.

The Aluminum Sleeve

Charcoal comes wrapped in a foil sleeve that covers it partially, protecting approximately half of the stick. By holding the stick on the foiled part, the artist can use the charcoal without getting dirty. But it must be removed as the stick wears down or breaks.

The foil sleeve is removed as the charcoal stick gets smaller from use.

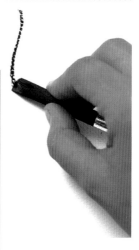

MORE INFORMATION
• Charcoal **p. 14**
• Sanguine Crayons **p. 18**
• The Chalks **p. 22**
• Chalk or Hard Pastels **p. 24**
• Dry Media **p. 26**

Some brands of sanguine bars or commercial pressed charcoal are sold wrapped in embossed paper for better protection. To use them, the paper is simply removed.

A Special Holder

For those who draw with charcoal often, there are special holders that can be used with the charcoal stick. An outside ring that can slide up or down will squeeze the charcoal stick and hold it properly in place. When more stick is

Any part of a small piece of vine charcoal can be used for drawing. The same is true for a piece of sanguine crayon or chalk.

Thicker charcoal sticks usually have a foil sleeve that partially covers them, but not the thin or very thin sticks.

Be Careful with the Lead in the Holder

The point of the lead that protrudes from the wood sheath or holder is the part that is used for drawing. If the point is too short, the pencil's wood or the metal of the mechanical holder will scratch and damage the paper when drawing, shading, or coloring with the point, whether it is charcoal, sanguine crayon, or chalk.

The metal ring of the holder will touch the paper when drawing, shading, or coloring with a point that is too short. It can even tear a paper that is very thin.

The wood casing can damage the paper when drawing, shading, or coloring when the point is too short.

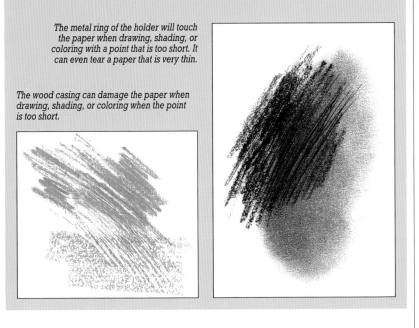

required, the ring is lowered, and the stick is moved up and held in place by sliding the ring back.

Any Part Will Do

Any part of the charcoal bar or stick, or the commercial pressed charcoal, sanguine crayon, or chalk can be used for drawing, shading, or coloring. Any loose piece is good also, and even the small fragments of broken lead can be used at any given time.

Even the Dust Can Be Used

The dust of the charcoal, sanguine crayon, or chalk that collects in the easel's receptacle can be gathered and saved in a container. Even this powder can be useful when shading, which is done with the fingers or with a blending stick.

The dust that is recovered from the easel is a mixture of dry media that can be used for shading.

WHAT TO DRAW WITH

The purpose of the line, the shading, or the coloring dictates which part of the medium to use. The bars are very versatile, and it is a good idea to become acquainted with the range of possibilities that they offer. Some effects require special procedures. To create very light and evenly applied shading and coloring the medium is used in powder form, spread with a cotton ball.

Fine lines can be created with both square bars and with pencils.

A pencil can be used to produce fine lines very easily, but to shade a large area the lines must overlap each other.

Using Corners and Edges

Fine lines are simply created with the pencil point. But using a square bar of compressed charcoal, sanguine crayon, or chalk for fine lines requires the use of the corners and edges. With the appropriate movement of the wrist pointing in the right direction, the edge can produce very fine lines.

Shading and Coloring

The pencil is used for shading or coloring without visible lines, making them close together to cover all the surface of the paper. This requires much practice and patience.

A square bar or a charcoal stick can be used to shade or color large areas with strokes that are hardly visible. The bar is simply broken and a piece of the required size is used to apply the medium by softly rubbing with the sides, using circular motions.

Background Techniques

To create a soft, even, and very faint background, it is not recommended to use either a pencil or a bar.

A piece of a sanguine bar can be used on its side to draw. A bar can easily make wide or fine lines.

To create fine lines using the edge of a square bar, the hand must hold it the correct way and draw with it appropriately. The easiest lines to make are straight verticals and straight horizontals, whereas drawing circular lines or in any other direction requires a steady hand.

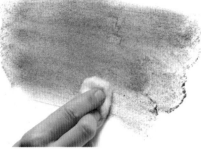

To apply a dry medium in a very light and even layer, it should be in powder form and spread with a cotton ball.

Different tools are used for different techniques (evenly applied, shaded, layer over layer) to create different effects.

Cotton Ball. The medium in powder form is used because it is so direct and is applied with a cotton ball. A little bit of powder is picked up with the finger and gently applied on the paper, then spread to create the desired tone.

Brush. The other tool that allows the creation of soft backgrounds is the brush, especially the fan-shaped brush. With it the artist can apply color evenly, or create large gradations or streaks and texture to express depth.

MORE INFORMATION
• The Line **p. 60**

Applying Pressure Gradually

It is important to press the pencil point, the edge of a bar, or the side of a fragment very lightly at the beginning so the line created is soft. Keep in mind that when using a dry medium, lines, as well as light layers of shading or color, can be superimposed.

However, when the lines are very strong, it is difficult to correct them unless they are erased. Keep in mind, though, that the blending technique will only soften the tone but not make it disappear. When you are not too sure about how the line should appear on the paper, it is advisable to make it very light and to darken it later when its placement has been confirmed.

A brush charged with the powder from blue chalk, for example, can be used to color the paper using circular motions.

VOLATILITY OF THE MEDIUM

The fact that dry media are volatile can be a problem for conserving the work, but this very quality is what produces certain results that cannot be achieved with other media. When drawing with a dry medium, part of the powder adheres to the paper and some of the particles remain on the surface. This powder can be removed or used for wiping, shading, or blending.

Volatility and Conservation

When the drawing is approached as a sketch, using dry media such as charcoal, sanguine crayon, or chalk, it is presumed to be temporary. It is most of all a preliminary study for a future project to be created with a more durable and resistant medium, such as oil or acrylic. The dry media are so fragile, especially charcoal and chalk, that it is recommended to keep these drawings only until the project is produced in its permanent medium.

Most artists save only the drawings that may be considered a masterpiece in their own right, because of their degree of synthesis and the artistic quality of the lines. In such

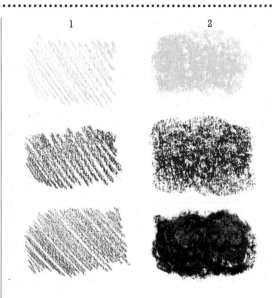

Lines (1) or areas of color (2) can be used for shading when working or for coloring with sanguine crayons or chalk.

cases, it is worthwhile to frame these small studies.

It is also true that some artists specialize in one of these dry media, normally sanguine crayons or charcoal. Their work in this case has great artistic value and deserves to be mounted with a permanent frame that enhances its beauty.

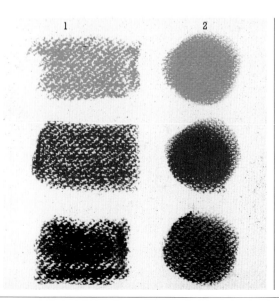

Whenever the artist uses light pressure to apply the medium (1), little white dots appear where the paper is clean. When an application is rubbed (2), the little white dots on paper tend to disappear.

1

2

*The blending done with your finger (1) is different from that done with a cotton rag (2).
The effect with the finger is darker than with the cotton rag. The latter, if pressed too hard,
removes a lot of powder but leaves a strong mark.*

The Ability to Blend

The great volatility of dry media is the characteristic that makes them ideal for blending. The most volatile is charcoal followed by chalk, and the one that best adheres to paper is the classic sanguine crayon. This means that it is relatively easy to spread charcoal, sanguine crayon, and chalk applications on paper with a cotton rag or with any other tool, as long as they have not been conserved. The act of wiping or blending implies the reduction of tone and value until they are eliminated.

Rubbing Versus Blending

Rubbing is different from blending in that the intention is not to remove the powder but to obtain an even tone. The volatility of dry media makes it possible to repeat this operation until the required effect is achieved. In other words, a finger can be used, for example, to remove powder from one area and to transfer it to another, repeating the action until the desired quality is achieved.

A rubbed area saturates easily; therefore, rubbing is pursued only when necessary.

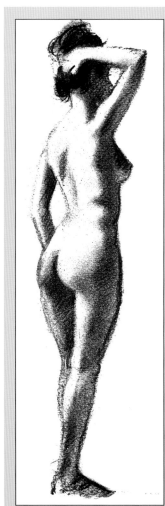

The Subtlety of Blending

Blending immediately reduces the tone of the colored or shaded area passing through various tones in a natural way. The simple act of wiping a cotton rag over an application created with a dry medium produces delicate blends without much effort. Practice will enable you to use the correct amount of pressure with a single motion of the hand to achieve the desired effect.

The right tool must be chosen every time the tone is adjusted by blending, be it the finger, a cotton rag, or a blending stick. The goal is a good representation of the tonal value.

TAKING CARE OF YOUR HANDS

For the artist who works with dry media, the hands are the best tools. This is why they must be given special attention with respect to their use and maintenance. The fingers can add or take away the medium. How dirty, clean, or wet the hands are is another measure of their usefulness as tools.

Hands Get Dirty

When a drawing is created with dry media, the fingers that hold the bar get dirty. At the same time, the backs of the fingers, by the simple fact of touching the drawing, end up being covered with residue. And when the hands or the fingers are used for blending or rubbing the medium, they also get dirty from the area they are working.

Frequent Cleaning

Even when the hand is simply used for holding the charcoal, sanguine crayon, or chalk stick, without using it for any other procedure, common sense suggests cleaning the fingers once in a while, with a dry rag or with water (in which case you must wait until the hands are completely dry before resuming), so the paper does not get dirtied by accident. Examples include cases in which the work is held on a nonprotected area, or when a dirty finger touches the paper when positioning the hand to execute a complicated line.

Using Your Hands

Hands and fingers are used for blending and rubbing because the moisture of the skin, even the small amount of oil that they secrete, is useful for this purpose. But a very different result is obtained when rubbing or blending with a finger that is dirty or charged with pigment, or with a finger that is clean. In each case, the fingers or the part of the hand that is to be used should be kept clean.

Reducing the Tone

When removing charcoal, sanguine crayon, or chalk is the intention, the hand, finger, or fingers must be completely clean. To be able to proceed gently, the artist must wait until his or her hands are completely dry after washing and

Dry medium can be removed from your fingers by rubbing them with a sponge that is dampened and squeezed dry.

have recovered their natural moisture level.

Adding Tone

In some cases, instead of reducing the tone by blending it, the goal is to darken it.

Then, the medium in the drawing is reinforced by rubbing with the residue of

A cotton rag can be used to clean the fingers and hands superficially.

This can be repeated, wiping more vigorously with the rag.

Volatility of the Medium
Taking Care of Your Hands
A Steady Hand and the Mahlstick

57

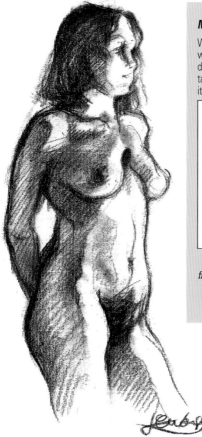

This sketch by Miquel Ferrón is a good example of clean work in which the artist has been careful not to touch the drawing with soiled fingers.

Mixed Techniques

When changing media, for example, in a project with the technique *à trois crayons*, the artist must decide when to use a clean finger and when to take advantage of the powder on the finger to mix it with the area that needs to be touched up.

When working with mixed techniques, a different finger is used for each medium if the artist does not wish to mix them. On the other hand, if the goal is to create mixtures, the fingers can be alternated.

When the hands and fingers are too dirty for the required task, they must be wet washed. For this, a sponge dampened with water can be used to wipe the fingers to remove the residue of charcoal, sanguine crayon, or chalk.

Only once in a while during the project, and obviously when it is finished, are the hands washed with running water and soap.

charcoal, sanguine crayon, or chalk that has adhered to the fingers.

How to Clean Your Hands

Hands and fingers can be cleaned with a dry or wet rag. When they are not too dirty, it is sufficient to repeatedly wipe the parts of the hand that are dirty with a cotton rag that is as clean as possible. The rag should be shaken occasionally to remove most of the dust to be able to continue using it.

When the drawing is wiped with a clean finger, a lot of charcoal is removed. It is difficult to create dark tones this way.

When fingers charged with charcoal are wiped on the drawing, the powder clinging to them is transferred onto the paper, creating more varied tones.

A STEADY HAND AND THE MAHLSTICK

To draw it is necessary to maintain good control of the bar, pencil, charcoal holder, or blending stick. The position of the hand and fingers that hold the tool must make this possible, even though at times this may require the use of a mahlstick. The difficulty stems mainly from the fact that it is not advisable to touch the paper within the area of the drawing.

Contact

To guarantee the quality of the line, the drawing tool is the only thing that should touch the paper, whether it is a stick or the point of a pencil or a holder. In the same way, we can be sure of the results when blending if the point of the blending stick is the only thing in contact with the paper or on the media that has already been applied.

When the charcoal pencil is used, only the point should be in contact with the paper. The hand should not drag over the surface of the drawing.

A Steady Hand

Touching the paper or the drawing with any part of the hand should be avoided. A steady hand allows us not only to exercise absolute control of the line but also to maintain the hand that holds the tool in the air without touching the paper. This is how a drawing executed with dry media is normally done.

To make a wider line, only the side of the charcoal bar should be in contact with the paper.

When the side of the sanguine bar is rubbed against the paper, an effort should be made not to touch the drawing with the fingers or the lines could be rubbed by accident.

When Support Is Needed

For some particular details, such as a short line that requires great precision, the little finger, completely clean, can be used to steady the position of the hand.

However, during the process of drawing with charcoal, sanguine crayon, or chalk, it is very likely that the artist will execute a long, precise, and risky line that is not a good idea to

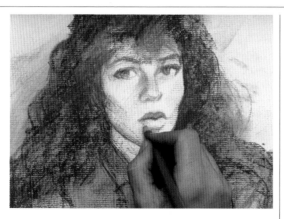

No matter what the position of the fingers that hold the pencil, dragging their backs or the back of the hand on the drawing should be avoided.

Artistic Lines

The surer and steadier the hand of the artist, without resorting to the use of a mahlstick or other supports, the more artistic the resulting lines and the work in general. But this demonstration of abilities is the result of innumerable hours of work, of analysis, of trials, of many discarded sketches. Draftsmen, and especially artists, are formed by tenacity, obstinacy, and years of dedication. Observation is integral to learning to draw. After analyzing the subject, the artist can go on to form the mental image of how the line should look.

correct. It is in cases like this one that a point of support is required.

To help increase the steadiness of the hand doing the drawing, the free arm can be used as support. However, this requires having an easel that holds the drawing surface firmly to keep both hands free.

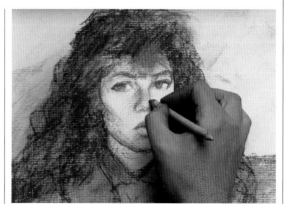

To control the results of the blending stick properly, only its point should be in contact with the paper.

> **MORE INFORMATION**
> • The Line **p. 60**
> • Hatching **p. 62**
> • Alternating Techniques **p. 74**
> • Lines Highlight Contours **p. 84**

The Mahlstick

Any long stick can be used as a mahlstick. The ones available from art supply stores have a ball on one end, which is the part that rests on the surface. The mahlstick is used by placing one end outside the work area and holding the other end with the free hand. The mahlstick can be positioned at any required angle so that the hand used for drawing can rest comfortably on the secured mahlstick.

The mahlstick can be used to steady the position of the drawing hand.

TECHNIQUES AND PRACTICE

THE LINE

The drawing is carried out by developing the technique of the line. A line can be described by its thickness, its trajectory, and whether it is straight, curved, or mixed, depending on the gesture of the hand. A line also has a starting point and an ending point. In a drawing, the ideal positioning of both points and the trajectory in between can be achieved only with practice.

Straight Lines

A straight line follows the direction of the shortest way between two imaginary points, which indicate the beginning and ending. The easiest lines to create, because they are so common, are first the vertical lines and then the horizontal ones. Any other type of line requires some planning to be able to execute their different points and their distance.

Curved Lines

Curved lines, which are used to represent circles, ovals, or simple arches, require

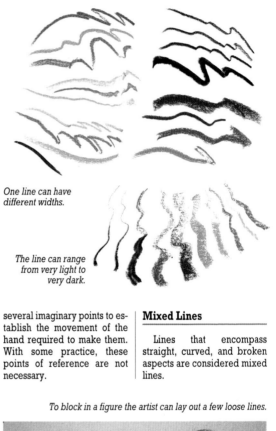

One line can have different widths.

The line can range from very light to very dark.

several imaginary points to establish the movement of the hand required to make them. With some practice, these points of reference are not necessary.

Mixed Lines

Lines that encompass straight, curved, and broken aspects are considered mixed lines.

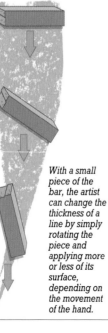

With a small piece of the bar, the artist can change the thickness of a line by simply rotating the piece and applying more or less of its surface, depending on the movement of the hand.

To block in a figure the artist can lay out a few loose lines.

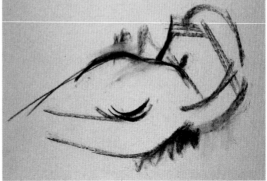

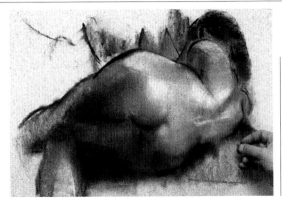

The loose lines are not visible once the drawing is finished.

with the paper. When the medium is pressed hard on the paper, the resulting line is darker and wider as well. The lighter the pressure applied on the bar or pencil, the thinner and finer the line will be. Therefore, to form a line, several questions are considered at the same time: the direction, the width, and the intensity.

These lines are made with a steady hand and good control of the tool. The resolute intention of the artist is also a contributing factor.

Width and Intensity

Other essential elements for executing the line are its width and intensity. A stroke is wider if the artist begins with a line that has more surface contact

The Artistic Lines and the Profile

Artistic lines are especially used to represent profiles. These lines, which stand out in the drawing, dramatize and emphasize the shapes, creating blocks that indicate volumes, light and shadow, and so on. It is important to understand the difference between those types of artistic lines and the regular lines that define the silhouette of a form, providing only an interpretation and a flat version.

Édouard Manet, Portrait of Madame Jules Guillemet. Hermitage (Saint Petersburg, Russia). Drawing with charcoal. Notice the precision and the artistic value of the lines, which are few but absolutely descriptive.

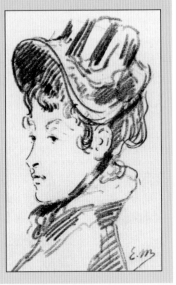

In this sketch for the study of a figure, Badía Camps shows us how a few lines can perfectly describe the essential folds of the clothing.

The Artistic Line

As opposed to the sketch, in which the direction and the placement of reference points is approximated, the artistic line is made with a sure gesture, representing the interpretative ability of the artist, and will probably remain untouched.

HATCHING

To shade an area using charcoal, or to color it with sanguine crayon or chalk, the medium can be used to create lines or even points to make hatching. The direction of each line and of the hatching in general should be laid out according to the vanishing point that corresponds to the subject being drawn.

Hatching Technique

Hatching can be created from lines. One of the simplest ways consists of drawing a few parallel lines close to each other. This group of parallel lines constitutes the first series. Over the first series, another series can be drawn in a different direction, and so on.

Other hatching. In fact, there are many types of hatching. The artist must use one type of hatching or another, depending on the interpretation and the desired effect of the drawing. For example, hatching can be created with pointillism or with scribbles. The tone will be lighter with spaced dots and scribbles, and darker with more dots or scribbles in the same space.

The direction. The direction in which each series of hatch lines are drawn depends on the type of perspective,

whenever the object represented has flat sides. To represent a spherical or cylindrical form more appropriately, hatching with curved lines is used.

A series of parallel lines can be made with the corner of a bar to create simple hatching.

Drawing Lines with a Bar

The corners of a square bar make it possible to create fine lines. But to create even thinner lines it is necessary to use a sharpened point of a

Hatching with a series of superimposed parallel lines can be created with a well-sharpened charcoal, sanguine crayon, or chalk pencil.

The three directions of hatching that dramatize a parallel perspective or single-point perspective are vertical, horizontal, and that which corresponds to the vanishing point.

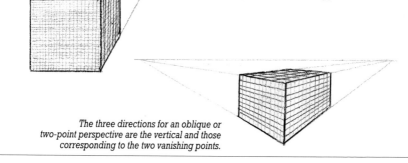

The three directions for an oblique or two-point perspective are the vertical and those corresponding to the two vanishing points.

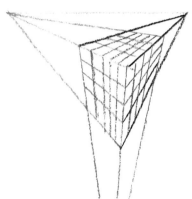

In an aerial perspective, the three directions are those that go toward each one of the three vanishing points.

charcoal, sanguine crayon, or chalk pencil.

The molded corners of a bar last a long time before they wear out completely. Besides, you can get four new short edges by cutting off a piece, and you can scrape the bar with a craft knife to make more sharp edges.

Fine Line Hatching

The lead or the thickest stick used with a holder make

lines even finer than the edges of a little square bar. But they cannot be compared to the fine line that can be created with a graphite pencil.

Making fine hatching with dry media requires sharpening the pencil often and not applying too much pressure on the paper. This is the reason why with dry media, shading or coloring with hatching is used less than shading or coloring without them.

MORE INFORMATION

- A Steady Hand and the Mahlstick **p. 58**
- The Line **p. 60**
- Alternating Techniques **p. 74**
- Lines Highlight Contours **p. 84**
- Receding Lines **p. 86**

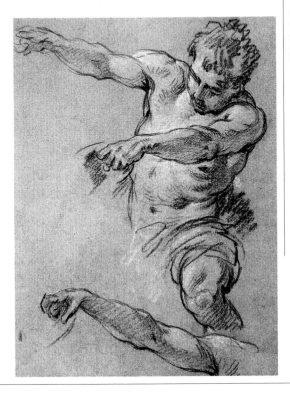

In this sketch there are areas shaded with visible lines and areas shaded without hatching. François Boucher (1703–1770). Study of a Male Figure. Vine charcoal with white chalk highlights.

SHADING AND COLORING WITHOUT HATCHING

The simplest way of shading with charcoal or coloring with sanguine crayon or chalk consists of using a piece of a bar with gentle circular or back-and-forth movements. With objects that have flat sides, shading or coloring can even be homogenous. With oval surfaces, on the other hand, a gradation is more appropriate.

A Piece of Bar

Depending on the size of the shaded area you wish to make, break a piece from a bar about ¾ inch, 1 inch, or 1½ inches (2, 3, or 4 cm) long. This piece is held so that the entire side is in contact with the paper. The same applies if it is a piece of vine charcoal.

The size of the piece should allow the medium to be applied with appropriate control, especially if drawing a specific outline.

The paper can be colored with soft circular motions when using a piece of sanguine crayon or chalk.

Covering Motions

If the area of the drawing requires an even value, it is simple to use circular movements with very light pressure. Layer over layer, the charcoal, sanguine crayon, or chalk is built up in a controlled manner. Continuing with the circular motions, the artist may apply the medium in either direction until the required surface is covered.

With a piece of vine charcoal, an area can have overall shading without any visible lines.

MORE INFORMATION

- Blending **p. 66**
- Rubbing **p. 70**
- Gradation **p. 78**

Back-and-Forth Motions

A back-and-forth movement is appropriate, for example, for modeling certain forms in a figure. The wide lines follow the best direction for representing each volume.

Also with a Pencil

A large area of the paper can be easily covered with a piece of bar, but it is also possible to do it with a lead, even though the task can be more involved. If a charcoal, sanguine crayon, or chalk pencil is used, a series of parallel lines can be made close together, without any white spaces in between. With a second series over the first, placing them in a different direction, the application can look very even without the lines being noticeable.

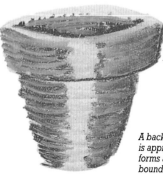

A back-and-forth movement is appropriate for creating forms and volumes within the boundaries of the outline.

With a sharpened lead or with charcoal, an area of the paper can be covered with parallel lines that follow the shape of the body while producing the required tone.

It is not always possible to make fine lines unnoticeable, and it is very common to have to superimpose more hatching over the previous.

Circular and Back and Forth

With practice, both movements, circular and back and forth, are alternated depending on the surface to cover and the intensity of the charcoal, sanguine crayon, or chalk required. The idea is, after all, to model the volume, and with

The Stuffed Dog, by M. Braunstein. The feeling of volume is achieved by making a circular line of the lightest tone of each color in each one of the areas with most light.

each stroke the artist makes the most descriptive movement when applying dry media.

Shading with a Powdered Medium

To create a homogenous area it is sufficient to use charcoal, sanguine crayon, or chalk powder with a blending stick, a cotton ball, or even the finger. In this case, the strokes will immediately acquire the look of a blended or rubbed area.

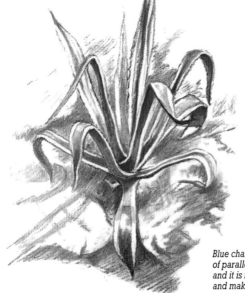

Blue chalk is applied by superimposing layers of parallel lines or with back-and-forth motions, and it is finished by retouching with the fingers and making white areas with an eraser.

BLENDING

The blending technique is without a doubt one of the most characteristic of the dry media. It is important to take into account its wide range of possibilities and to know how to use them when needed. Thanks to blending, the artist can create delicate gradations, which are the basis of the dry media's chiaroscuro. This technique can be applied by using various tools, each of which produces somewhat different results.

The Act of Blending

By definition, blending consists of wiping an area covered with a dry medium—charcoal, sanguine crayon, or chalk—with a cotton rag with the intention of spreading it until it disappears. This is suggested by the Italian word *sfumato* (shading). The results of this action depend on numerous factors. To begin with, the effect is different according to the tool that is used. The amount of pressure applied with the tool also makes a difference, as does the direction in which the tool is used.

More or Less Pressure

Depending on the characteristics of the tool used for shading (a cotton rag, the hand, a fan-shaped brush, a cotton ball . . .), there are some observations to keep in mind. With some tools, applying too much pressure on the drawing done with a dry medium may result in rubbing rather than blending. To blend without causing the powder particles

Effects of charcoal (a), compressed charcoal stick (b), and charcoal pencil (c) when blended with 1, a cotton rag gently; 2, a cotton rag with a lot of pressure; 3, a fan-shaped brush; 4, a cotton ball. The stick and pencil can be rubbed only by pressing hard and repeatedly.

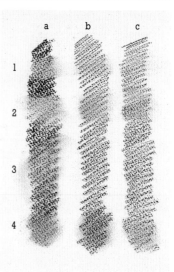

to adhere even more to the paper, it is important to make quick wiping motions, as if brushing.

The Ideal Tool

Each tool or implement creates a specific blending effect.

A clean cotton rag can be used to remove a lot of charcoal, sanguine crayon, or chalk and to spread the shading, which will softly fade away.

The softest and most delicate blending is done with a fan-shaped brush or by wiping softly with a cotton ball.

A gradational effect can be created relatively easily by blending a solid area made with two tones in charcoal, sanguine crayon, or chalk.

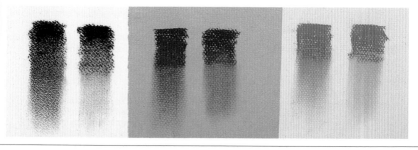

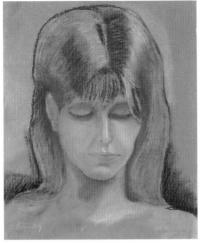

Blending can be used to mix two dry media, like charcoal and chalk. M. Braunstein, in his Study of the Head of a Young Woman, *has explored all the possibilities of chalk and charcoal using blending and gradations.*

The Direction

The effect resulting from blending is very different, depending on the direction in which it is done. As will be seen, with the blending technique the artist can immediately create a superb gradation of delicate tonal richness. Depending on the direction of the blending, the gradation can vary from lighter to darker or vice versa, when done vertically, horizontally, or in any other direction.

Differences Between Dry Media

The quality of the blending not only depends on the tool, the intention of the artist, and the pressure and direction in which it is applied, but is also subject to the characteristics typical of each dry medium, and to the possibilities of using two or more dry media at the same time. Charcoal is the quickest to disappear when blending. With sanguine crayons, blending is achieved in part by rubbing. And chalk, applied very lightly, can be blended without rubbing.

When to Retouch

One of the most important questions for work done with any dry medium, whether charcoal, sanguine crayon, or chalk, is to decide when an area or line must be blended—in other words, retouched. The tonal value is one of the most common reasons for ongoing deliberation. That is, an area that is too dark is reduced by blending it. But this technique is also used for mixing colors and for grading shaded areas.

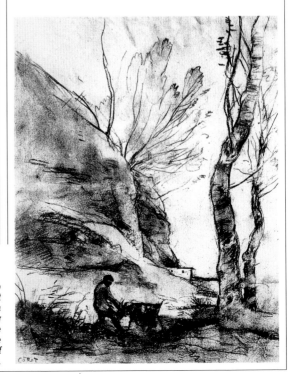

Blending causes a line or area to decrease in tone or value. Corot (1796–1875) used shading in certain areas of this drawing to create more depth in the landscape and to maintain the contrast with the sharpness of the contour lines.

TONE AND TONAL RANGE

The representation of a model that has been drawn from life is an organized system of tonal values. Therefore, tone and tonal range are vital concepts in drawing. The greater or lesser amount of pressure with which a medium is applied to paper produces different tones that can be done in an organized fashion.

Tone Is a Value

Value is the concept that describes how a line or area appears on paper. If the pressure applied to the bar or the pencil is very gentle, the value will be very light. The harder the pressure on the bar or pencil, the darker the values.

Comparing Tones

When talking about one tone being light and another being dark, a relationship is being established between the two by comparison. When artists make drawings, they are constantly comparing tones

When the pressure applied by the medium to the paper is gentle, the marks will have a very light tonal value.

When a lot of pressure is applied by the medium to the paper, it leaves dark tone lines and a general tonal value that is also dark.

and values, that is, pondering whether one tone is lighter or darker than another. When the lightest tone of all is established (which is the white of the paper, when white paper is used) and the darkest (the darkest tone is obtained when maximum pressure is applied), the remaining values are

Comparison of the Various Techniques

The most extensive tonal range is the general one, which includes all the ranges obtained with different techniques. It consists of comparing the effects produced by each technique and rating the different tonal ranges among them. There are enormous possibilities for producing different values, some of which create valuable contrasts for enriching the drawing by creating a sense of depth, modeling volumes, and describing shapes.

MORE INFORMATION
• Gradation **p. 78**

The different semitransparent tonal values can be arranged as follows: 1, tones produced by shading or coloring without visible lines; 2 and 3, tones created with hatching composed of fine lines.

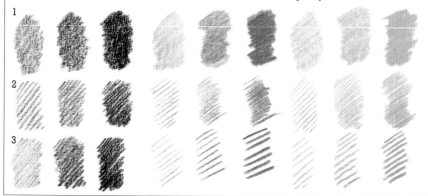

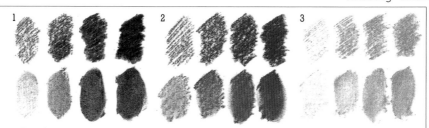

A tonal range consists of an organized series of many tonal values that progress gradually without sudden tonal changes, created without blending or rubbing (see above). Any tonal range can be rubbed (see below), which results in a tonal range with a different effect. 1, charcoal; 2, sanguine crayon; 3, chalk.

between those two. By comparing them with one another, they can be arranged by tone from the lightest to the darkest, or vice versa.

Tonal Range

A tonal range is a series of perfectly organized tones, without tonal gaps, from lightest to darkest or vice versa. The direct tonal range is created by shading with charcoal or by coloring with sanguine crayon or chalk, making different tones that gradually range from the lightest to the darkest, or vice versa. A tonal range can be created by blending the direct tonal range. The tonal range created

The color and tonal ranges produced with different chalks and layering them on colored paper make it possible to create rich color compositions.

with hatching is made by drawing crossed lines with gradual intensity. Therefore, a tonal range can also be created by blending the one created with hatching.

Mixtures and tones. When the artist mixes different colors and media in a project, different tones of each mixture can be created by applying white chalk.

Sanguine crayon can be blended with the fingers, creating a different effect from that of sanguine that has not been retouched.

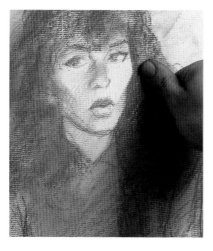

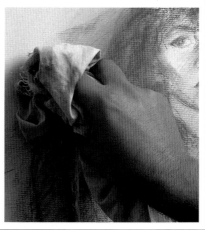

The background tones can be rubbed or wiped away by wiping with a rag.

RUBBING

When rubbing is to be used, the results on the line or area of color are different from those made by blending, because the former is darker. Rubbing saturates the paper much faster, so this technique is to be used only when necessary and applying it with the appropriate tool for each situation.

A drawing that has not been touched up presents an overall light tone and appears very clean.

When the drawing is shaded and blended with a brush, as in this case, the resulting effect is much darker and less crisp, but it immediately suggests depth.

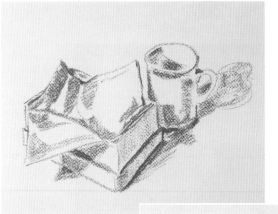

Blending and Rubbing

When the drawing is blended, depending on the medium and tool that is used, as well as the pressure applied, there is a certain fusion of the powder particles. Blending is based on a single and firm intervention. On the other hand, blending implies repetition. The procedure is repeated until the tone has been evenly blended or the specific mixture has been achieved.

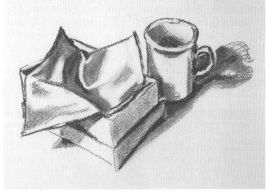

What Is Rubbing?

By repeatedly rubbing a dry medium already on the paper with a tool, several things are accomplished. On the one hand, sudden tonal changes are minimized or two different media are completely mixed. But rubbing the same area insistently also forces the powder particles to adhere more deeply to the surface of the paper. For example, when the artist uses a heavy-grained paper, lightly drawing or coloring shades or colors only the high areas of the paper. When the powder is rubbed, this procedure shades and colors all of the paper, including the lowest areas of the surface.

Rubbing Tools

Rubbing can be done with any tool that will press the powder onto the paper.

The fan-shaped brush is, of all the tools, the one that applies

MORE INFORMATION

- Tone and Tonal Range **p. 68**
- The Hand and Fingers **p. 72**
- Alternating Techniques **p. 74**

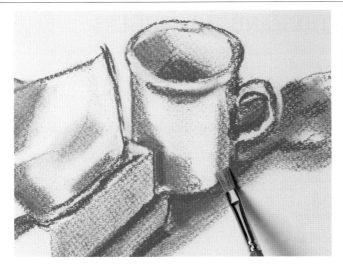

A brush makes it possible to spread the chalk very gently in any direction to better describe the volume.

the least pressure. Therefore, it is the least recommended for rubbing. The ideal implements are the fingers or the blending stick, although there are other tools that are good for rubbing.

The Purpose

Rubbing allows the artist to apply an even tone and also to create other effects, like softening gaps between tones. In addition, it is a good procedure for evening out a mixture when two different media or two or more colors are used with the same medium, such as sanguine crayon or chalk.

Regarding Paper Saturation

As the applications and rubbing progress, it is easy to reach a point where the surface is saturated and does not accept more pigment. Not all papers become saturated at the same rate. The artist must experiment with the drawing paper that he or she uses to become familiar with its adherence and saturation characteristics. In any case, rubbing should not be overused, and this technique should be reserved for necessary cases.

Small areas and details can be rubbed with the blending stick.

THE HAND AND FINGERS

By far, the best tool for working with any dry medium is the hand. The fingertips
and other parts of the hand are ideal for direct contact with the medium.
The applications may be very small, only for details, using one part of the tip
of a finger, or very large, using the entire palm of the hand.

No Tools Needed

When the fingers or other parts of the hand are used for blending or rubbing the dry medium already applied on the paper, they come in direct contact with the powder. It is possible to feel the movement. The artist experiences not only the physical sensation, but also a close, automatic reaction that affects the result.

The movement of the fingers on the dry medium that is already applied on the paper, whether charcoal, sanguine crayon, or chalk, is like a caress. The movements are not harsh. The fingertips glide over the surface, thanks to the inherent characteristics of the particles that are in all dry media.

MORE INFORMAITON

- Blending **p. 70**
- Gradation **p. 78**

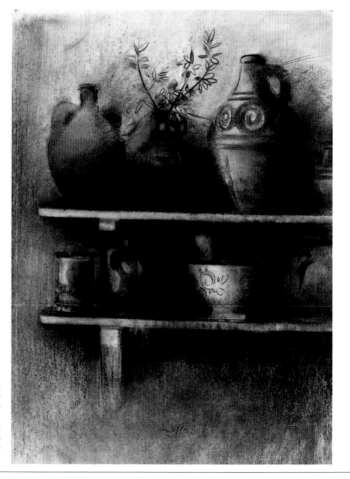

Here is an example of how to use the blending and rubbing techniques to give form to various shapes using only charcoal and sanguine crayon.

Every fingertip can be used for blending or rubbing.

For shading large areas, the side of the little finger and the side of the palm of the hand are used.

The thumb, because of the way it can move, is used for shading gently with circular or arc-like motions.

A large area can be shaded using the thumb down to its base with fan-like motions, using the dot as the pivot point.

A large area can also be shaded using the side of the thumb and its base, sliding the entire hand.

The high areas at the bottom of the hand are ideal for blending and rubbing.

The Fingertip and Side

The tip of any finger is, without a doubt, its most useful part. It is very practical for rubbing with circular motions, or for applying pressure to an area from top to bottom, left to right, or in any other direction.

The side of the fingertip can be used for rubbing specific and small areas.

The tips or the backs of two or more fingers can also be used at the same time. If they are used in a single quick wiping motion, they are good for blending. A larger area can be rubbed by wiping repeatedly with the tips of two or more fingers put together.

The Movement of the Thumb

The movement of the thumb can be used to make quick blends with a sweeping, fan-like motion. This is the most practical finger for directly blending and modeling cylindrical volumes and similar shapes.

Other Parts

The thumb and its base to the palm of the hand can be used for blending a much larger area. The side of the little finger and its extension to the palm of the hand can also be

used for blending large areas. The latter is used with the typical sweeping motion.

A Finger for Each Medium or Color

When the drawing is made using mixed techniques, it is common practice to assign different fingers to each medium or color. But keep in mind that the most useful are the thumb, and the index and middle fingers.

ALTERNATING TECHNIQUES

Several techniques are usually involved in a drawing made with a dry medium.
The lines, hatching, shading, or coloring, either direct, blended, or rubbed,
are alternated until the work is completed. Decisions are made throughout
the entire drawing session, evaluating each line or area with respect
to the others and to the overall composition.

The Technique and Its Goal

Each technique must be used based on the desired results. The line technique is used for defining contours. Shading or coloring with or without hatching is used for modeling volumes. Blending and rubbing are considered touch-up techniques used for softening or for correcting the tone and the drawing. Another technique can be the one used for creating white areas, which can even require the use of an eraser when it is necessary to restore the white areas or the original color of the paper.

Each Drawing Is a Different Problem

A drawing normally uses several techniques combined. When the sketch has been established, the artist must begin to give volume to the forms, which is done by introducing light and shadow values. Different drawing and shading or coloring techniques are available for this purpose. When a light has been darkened by accident, the white space must be restored because this value is so necessary to give form to a volume.

The sketch for the definitive drawing is made with gestural lines to block in the head of the dog.

The shaded gestural drawing is not usually retouched. To be able to do that, the artist must have a lot of practice with quick sketches.

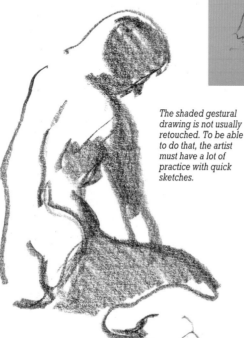

The Interpretation

In every artistic interpretation, there is concern with the form on one hand, and the color on the other. Form can create more or less of a likeness, whereas color allows the use of imaginary ranges of color and intensity that are not always realistic. Texture can also be manipulated, especially with dry media, which is the subject here. It is common to leave one area of the drawing unfinished. This introduces interesting contrasts and unreal or atmospheric effects that are very convincing from an artistic point of view.

Most of the drawings done with a dry medium include several techniques, as seen in this transitional step.

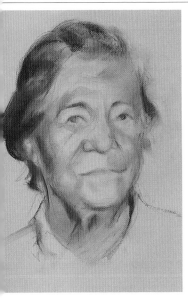

Myriam Ferrón uses sanguine crayon, brown and white chalk and charcoal on medium-grained, colored paper.

The Goal

The goal is to realistically represent the forms and volumes that are drawn from the model. The goal is to fully respect the system of tonal values established from this model. Therefore, it is important to create all the tonal values that are necessary for that end. The chosen tonal range will depend equally on the particular interpretation of the artist and on the combination of techniques that he or she considers appropriate.

MORE INFORMATION

- Rubbing p. 70

Ongoing Evaluation

Keeping in mind the system of values assigned for the interpretation of a model, only the ongoing evaluation will tell the artist if each tonal value is correctly placed and if it reflects the volumes as

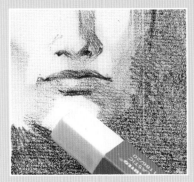

they are suggested by the model. This way the artist will know when to blend and rub, when to create highlights, and when to outline as needed. This is done by continuously comparing one value with another and all together as a whole. The final step consists of creating white areas.

For the largest areas of light, with a dry medium such as charcoal, the paper is manipulated with an eraser. Soft shaded or colored areas are used to represent the light. They can be touched up if needed to blend them or rub them with other neighboring tones.

TECHNIQUES AND PRACTICE

SPECIAL EFFECTS

Depending on the tool used for blending or rubbing and the way it is used, it
is possible to create special effects. But they can also be created by simply
leaving the paper without shading or coloring. To do this, masking is used
to protect the paper and to keep it free of the dry medium.

A Unique Mark

A number of materials or objects can be used either to apply the medium in powder form or alter the dry medium that is already applied, and to mask an area, or even apply the medium directly. A toothbrush, the teeth of a comb, a hairbrush, a dog brush, esparto grass, a piece of raw linen, the sole of a boot, a piece of potato or rubber, and a sheet of flat or corrugated cardboard are some of the tools that can be used one way or another to create different effects.

Masking

To mask off means to protect the paper so it will not be marked by the medium. A stencil or cardboard cutout can be used for drawing around the outside edge. Another system is to use the weave of certain cotton cloths

When a dry medium is mixed with white crayon, it becomes more resistant to both shading and coloring.

or cutout cardboard that allow the medium to come in contact with the paper through the openings. The texture created this way is very impressive if the intensity of the shading or coloring is strong. This technique is used to create an effect in avant garde work.

Special Handling

Cheesecloth, when used for blending, can create interesting textures. Sgraffito done with the teeth of a comb creates artistic lines according to the direction and strokes they make. A completely dry toothbrush can be used to create convincing volumes by blending.

The Kinetic Interpretation

Dry media are ideal for special effects that are difficult to create with other media.

Shading or coloring around cutouts used as masks can create unusual effects.

Dramatic Effects

When a form is altered by dramatizing some aspect, even if drawing from the model, it is more than stylizing, it is an abstraction with respect to the idea. A profile can be exaggerated, the figures elongated, tonal contrast increased But in the end, and despite all these artistic licenses, the overall work continues to have its own balance.

Water can be incorporated into the work with a clean brush, creating dramatic contrasts.

A simple eraser can be used to make white areas, which create something that only the immediacy of a photograph can capture: movement. This happens almost immediately with white areas that the eye mixes with the background to create this sensation in the viewer.

Mixed Techniques

With water. Although the mixed techniques using water can dirty the work if it is not carefully executed and done on an appropriate paper, it unquestionably adds a distinctive touch to the work that sometimes can be very interesting. It is a good idea to experiment with it to dis-cover the possibilities, keeping in mind that not all the dry media react to water the same way.

With white wax. Layering charcoal, sanguine crayon, or chalk on the paper with white wax results in a paste that eliminates the volatility of the dry medium and gives it much more adherence.

José Juan Agüera uses the technique of creating white areas to convey a sense of movement to both animals. He uses an eraser for the task.

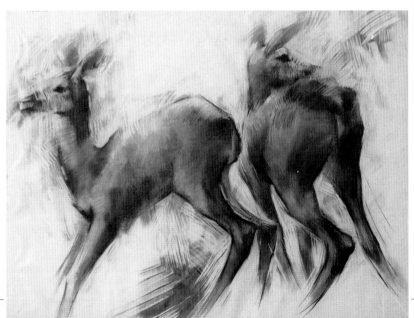

GRADATION

Gradation is one of the most common techniques in dry media, because the famous descriptive chiaroscuros that create shape and volume are based on this technique. The gradation of a color can be light or opaque, just like using two colors. Gradation is an easy technique to use because of the characteristics of all dry media.

Semitransparent Gradations

Different tones of charcoal, sanguine crayon, or chalk are used to make semitransparent gradations. A tonal range is created by applying one after the other without tonal gaps, gradually going from one tone to the next.

Opaque Gradations

When white chalk is used for highlighting, the appearance of some opaque tonal gradation is inevitable. In this case, the gradation is created with tones by mixing charcoal, sanguine crayon, or chalk with the white chalk. Opaque gradations are usually made by superimposing layers of gradation.

Gradations Between Two Colors

A gradation can also appear between two different colors of sanguine crayon, or chalk, charcoal and sanguine crayon, or sanguine crayon and chalk. A gradation of this type, based on mixing two different colors, is made step by step. The different values are created by mixing

A semitransparent gradation on white paper with charcoal, sanguine crayon, or chalk.

A semitransparent gradation on colored paper with charcoal, sanguine crayon, or chalk.

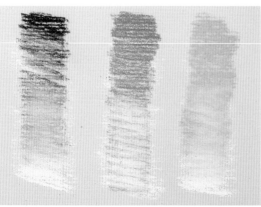

a large proportion of one color with a little bit of another directly on the paper, which creates the first value. Then, the first color is gradually mixed in a smaller proportion than before with a little bit more of the second color than before, and so on. This way, a series of orderly values is created until the last one is completed, which is

An opaque gradation using white chalk on colored paper with charcoal, sanguine crayon, and a different colored chalk.

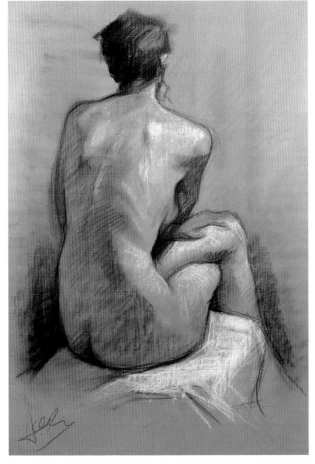

Miguel Ferrón draws on a light-colored sienna paper using sienna, sanguine, black, and white chalks, among other colors.

formed with a small proportion of the first color and a lot of the second.

Direct Gradations

For the artist who uses a dry medium, it is easy to create a direct gradation. It consists of controlling the pressure on the medium when applying it to the paper. Pressure must be increased gradually to create a gradation that goes from light to dark, or decreased gradually if the gradation goes from dark to light. Semitransparent gradations are the easiest to make. Opaque gradations created by adding white chalk are made

starting with a semitransparent gradation with charcoal, sanguine crayon, or colored chalk, over which another gradation of

white chalk is added, light over the dark areas going to dark over light, although an even application is also acceptable.

Gradations and Colored Paper

By building up pigment on colored paper, and by optical mixing, we can observe how a very dark tone smoothly passes to a very light tone, or vice versa.

These gradations are especially noticeable on colored paper, because white chalk, without any other color mixtures, creates highlights only if the paper is not white.

Gradations between two colors on colored paper involve three colors, which interact. Therefore, this system can create great chromatic richness with few parameters.

TONAL VALUES

To draw a figure from life a system of shading must be used. Only careful observation will ensure the accuracy of the representation. There are two basic areas to consider: a general area of light, and a general area of shadow. The analysis progresses by establishing areas of different values until the system of relationships is completed.

Observing the Model

Several areas must be located on the model. First, the darkest or most intensely shaded areas must be studied. Then, the lightest and most highlighted areas are identified. A general division is then established between the areas of light and shadow. Finally, at least three different values should be established in the light area and as many in the shaded area.

A good mental exercise consists of reducing the view of the model to two clearly differentiated areas: one dedicated to light and the other to shadow.

MORE INFORMATION
- Tone and Tonal Range **p. 68**

The Purpose of Values

The shading system is an analytical tool that helps to create a representation on paper, that is, on a two-dimensional surface, something that appears three-dimensional, with depth or volume. This system is based on the use of different tones or values in an achromatic, monochromatic, or full-color work, to express the gradual transition

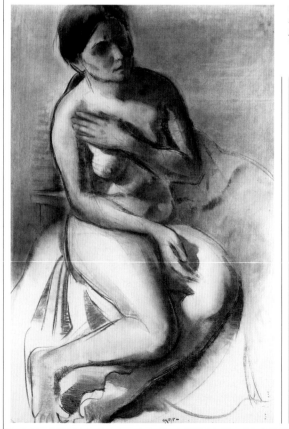

Charcoal drawing by Francesc Crespo. The perfect representation of light must be noted.

Tonal Sketches and Studies

It is very useful to make a simple study that defines the two large areas of light and shadow even before the sketch is created. This graphic aid will help enormously later in establishing the tonal sketch. The sketch roughly establishes the boundaries of the most important forms for the representation of the model. But a tonal study provides much more information, because even when it is done quickly, it indicates the areas that receive more light and those that are in shadow. Some studies even provide information about the bright areas (usually executed with highlights done in white chalk) and intense light, the darkest area, and two or three intermediate tones.

from the lighted area to the dark or shadowy area of the model.

Assigning Values

With what the artist can observe from the model, a relationship is established between the intensity of the light received by each area, and a series of tonal values that must

The model must be observed until several areas with different light intensity are located.

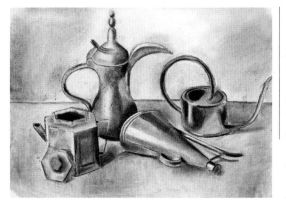

be created with the dry medium. This is nothing more than assigning values that make it possible to associate the specific degree of light from the model with a light or dark tone from the dry medium, keeping in mind that the tonal values must be properly interrelated overall to make a convincing representation.

For creating achromatic drawings, the artist has the tonal values of charcoal at his or her disposal.

A more in-depth tonal study establishes the values for the lightest and darkest areas, and also for some intermediate values.

The simplest tonal study provides information about the two most identifiable areas, light and shadow.

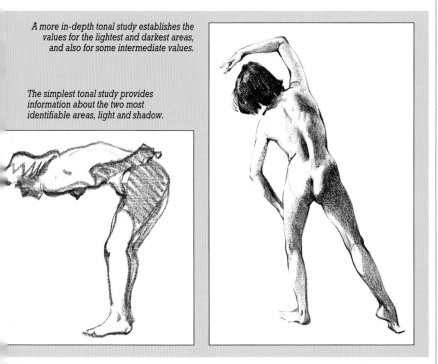

CHIAROSCURO

The most outstanding chiaroscuros created with dry media are accompanied by subtle gradations and blends. The secret lies in the way the medium is applied, be it charcoal, sanguine crayon, or chalk, and in how it is retouched later. Chiaroscuro is modeled based on light and its trajectory, and by the strength of the light advancing against the shadow.

Creating Chiaroscuros

All the operations used in the creation of gradations, over which blending and rubbing are created—in other words, the techniques that can be used with dry media—make it possible to draw chiaroscuros. The word *chiaroscuro* (meaning light and shadow) indicates the passage from light to shadow. A dry medium makes it possible to represent this passage with absolute credibility, whether with an achromatic medium (charcoal), a monochromatic medium (sanguine crayon, chalk), or a colored one (sanguine crayon, chalk).

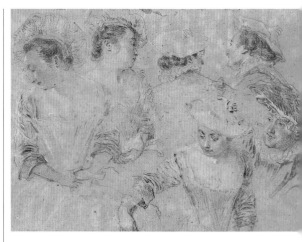

Antoine Watteau, Study of Three Women and Three Men Wearing Berets. *Produced with* à trois crayons *technique on beige paper.*

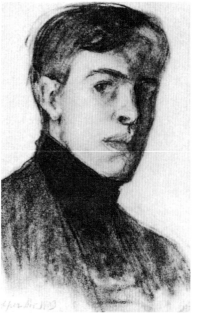

Edward Hopper, Self-Portrait. Charcoal drawing. National Portrait Gallery, Smithsonian Institution (Washington, D.C.).

The Direction

Gradation is carried out according to a plan, making the most intense application coincide with the darkest area of the model, and the lightest with the most illuminated area of the same form.

The direction in which blending is applied is very important. When it is done from the darkest area toward the lightest area, the result is generally darker, which shades the area that was lighter before. On the other hand, when the blending is done from the lightest to the darkest area the general result is much lighter and cleaner. The most appropriate direction for the blending should be chosen for each area of the drawing.

The Intensity

More of the medium is removed from the paper if the blending is done vigorously than if it is done softly. Therefore, the resulting intensity depends on how the procedure is carried out. The value range of the gradation must be corrected throughout the process, comparing it with the values of the overall drawing, for the representation (according to the interpretation) to be as credible as possible.

The Appropriate Tool

Any tool should be chosen based on the intensity and the quality of the retouching that is required. For an artist who works with dry media, the fingers are the best tools. However, when the blending or rubbing should be very light, it is best to use a fan-shaped brush, whereas a blending stick is used when the work calls for a more vigorous rubbing.

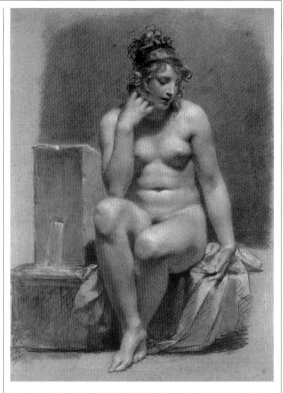

Pierre-Paul Proud'hon (1758–1823), The Fountain. *Clark Art Institute (Williamstown, Massachusetts). Drawing done with charcoal with highlights in white chalk on blue-gray paper.*

Chiaroscuro and the Background

One resource that shows off the enormous possibilities of chiaroscuro in a dry medium is the atmospheric treatment given to the area that surrounds the main subject. The foreground is developed with chiaroscuros that describe its volume. But the middle ground, and especially the background, are less detailed.

François Boucher (1703–1770), Naiades and Triton. *Sanguine crayon and black stone with white chalk highlights on beige paper. Wallace Collection (London, England).*

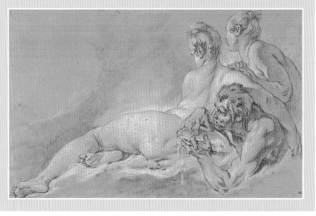

LINES HIGHLIGHT CONTOURS

Chiaroscuro is strengthened by strategically placed gestural lines that create a contrast between the foreground and the rest. The different line weights are used to convey an increased feeling of volume and depth. A heavy line indicates proximity, and a lighter line, distance.

Total expressiveness can be achieved in a sketch when it is executed with gestural lines.

within that range, those that are closest to the viewer must be darker, and lighter if they are farther away. This holds true for the figures in the middle

Only the Artistic Lines Remain

The artists who tend to begin the work with preliminary sketchy lines usually draw them very lightly. Once the outlines have been established, the permanent drawing is done with the required sureness and intensity. The sketchy lines disappear completely when they are covered by the final drawing or they become unnoticeable in contrast with the intensity of the firm lines. Those lines form an interesting background for the artistic lines.

Line Weight

The different techniques for drawing lines are applied when drawing contours and profiles. The outlines with more contrast should be those that describe the shapes in the foreground. At the same time,

Even when drawing a quick sketch, the darkest lines are reserved for defining the closest contours, whereas the more distant forms are described with increasingly fine lines.

The Style

Each artist develops his or her own style. The particular interpretation of the subject matter may have a higher or lower degree of abstraction. But the artistic line is always present, including in the most innovative work, even when the form is disfigured or the volumes modified.

A good contrast that consolidates the forms and enhances the depth is established using shading and coloring, with or without visible lines, and by varying line weights.

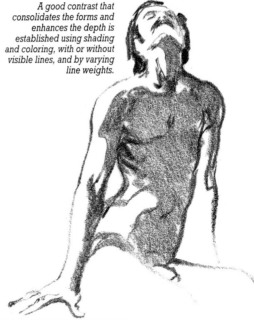

range and those farther in the background.

This orderly regression, more intensity and thickness of line for the nearest shapes, and progressively less intense for the more distant forms, is the ideal complement for the chiaroscuro in the drawing, and therefore for adding a dramatic element of depth.

The Artistic Line

The most artistic lines should be the closest ones, because we should not be using lines of a constant thickness and intensity to separate one shape from another. The weight and intensity of the line must be adapted as the work progresses to describe the characteristics of the volumes. The guideline that defines the characteristics of the most descriptive line is the one that respects depth and the play of light and shadow.

This academic nude on a sofa by Vicenç Ballestar, executed with charcoal pencil, sanguine crayon, and sepia and white chalks, shows the vitality of the gestural lines made with each medium.

RECEDING LINES

The great masters who pioneered the basic techniques of drawing established the use of so-called receding lines. These lines contribute a greater representation of depth. To be able to use them the artist must do a good job at locating the different planes and understand their depth well.

Receding Lines Express Depth

A receding line expresses the outline of the form being drawn. It is a type of artistic line that is drawn more intensely or heavily for the object closest to the viewer, and more softly and lightly for those farther away. These variations are depicted in a gradual form.

Observation and Reflection

A continuous and regular line defines the contour of a form. But a receding line is the result of observing the form

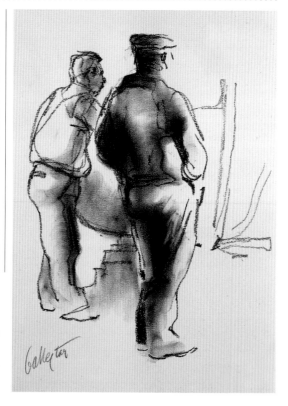

The quality of the sketch, from the first stroke, reinforces the possibilities of this spontaneous study, charged with interpretive force where the receding lines are put into play. Charcoal by Vicenç Ballestar.

and analyzing how it is presented with respect to the various vertical planes in which the scene is contained, as if they were topographical sections. Every contour begins in a vertical plane and progressively moves to the next.

This still life, done with sepia-colored chalk is a realistic drawing integrating the receding lines that add drama to the contours.

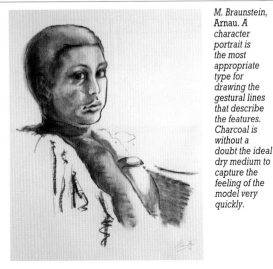

M. Braunstein, Arnau. A character portrait is the most appropriate type for drawing the gestural lines that describe the features. Charcoal is without a doubt the ideal dry medium to capture the feeling of the model very quickly.

A line that begins on a closer plane and goes to a farther one must decrease in weight and intensity. Any line that is initiated on a farther plane and moves toward a nearer one must increase in weight and intensity.

Form, Volume, and Outline

The outline of a human body or of an object is nothing more that its projection onto a two-dimensional plane, like the surface of the paper. For this outline, even a well-proportioned one, to express the volume of the body, it must include receding lines. Therefore, drawing first consists of knowing how to allocate proportions and how to block in the basic forms of the body on paper, and second, of how to use chiaroscuro and the contrast of receding lines to suggest depth.

Where It Begins, and Where It Ends

A receding line, even when it is done artistically, can be subject to errors if the proportions of the drawing and the scale of the format are not respected. It is very important for the line to begin and end without hesitation to represent the volume correctly.

A Very Common Mistake

The tendency of a beginner is to always draw lines of the same weight and intensity, in a way that they outline the form but do not contribute any major information to the representation.

The best advice, in cases where the artist does not have enough confidence to execute the lines in any other way, is to understand what a receding line is and to apply it over the outline in the sketch, which should always be light.

In The Baby's Stroller, *M. Braunstein shows the contours of the forms closest to the viewer, with vigorously executed lines in charcoal and receding lines to explain the volume better.*

DRAWING PROPORTIONS BY EYE

To create artistic lines the artist must be proficient at drawing proportions by eye, so an object can be reproduced in the appropriate scale with sure and steady strokes.

The Characteristics of the Model

The characteristics of the subject matter that can be observed from the artistic point of view are the shapes and dimensions of every single element, and of all of them as a group. The artist must evaluate color and tone to place the areas of light and shadow. But it is also important to consider the balance, the existence of a central point of interest, whether the composition has good rhythm, and so on. All of this must be analyzed before drawing begins. For this purpose, sketches, with all kinds of variations making it possible to become familiar with the problem, are very useful.

The Format of the Work

The paper is chosen according to the two basic dimensions of the subject matter, which are its height and its width, according to the desired framing. The simple proportion established between them serves as an indication of what type of paper to use, and it can even be cut according to that proportion. In general, both the drawing tablets and the single sheets of drawing paper come in rectangular shapes.

The Dimensions of the Paper

Formats vary from square to rectangular and can be used vertically or horizontally, depending on the requirement of the subject matter. With re-

A landscape is usually a simple subject to draw.

Although there are many trees, it is easy to establish the direction of the most important trunks.

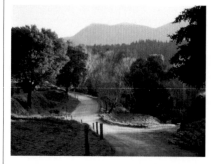
The shapes of the most important masses are placed around the center of interest, which is located without a problem close to the intersecting point of the diagonals.

spect to scale, dry media in general require working in medium or large format. The 12 × 18 inch (30 × 45 cm) tablets are without a doubt the smallest ones recommended for dry media, and they are especially ideal for quick sketches. The single sheets of 20 × 25 inches or 31½ × 47 inches (50 × 65 cm or 80 × 120 cm) are more common for the permanent work.

There are even rolls 3 to 4½ feet (1–1.5 m) wide by 30 feet (10 m) long. Since the medium we are working with is dry, it is better to choose large sizes that are of the proportions of the desired format.

The Scale

The subject represented on the selected paper can be smaller, the same, or larger than the real model. To establish this relationship the artist must keep in mind the scale of the drawing. This can be done quickly by noting the dimensions the way artists do and by applying them to the drawing according to the proper scale. If a is the width of the format (on the model) and b the length, visualizing them

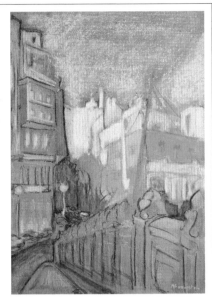

M. Braunstein, Gomis Street. Colored chalk. Measurements must be taken for an urban landscape like this one so the artist can block it in and apply the proper perspective.

The measurements are taken using the artist's method. Each measurement is taken from the same position, by viewing the subject from the end of the pencil to the height of the thumb, as shown in the illustration.

through the charcoal, the bar, the pencil, or a stick, it would be a' and b' on paper. If a is 1 inch (3 cm), for example, a' would be 19.5 inches (50 cm), and so on. All the measurements taken from the model with the pencil are related to one another. These dimensions are used as references so that when they are transferred to paper with the corresponding scale, they maintain the same overall relationship.

The Artist Takes the Measure

The artist stands in front of the easel or in front of the paper with the properly secured board, without moving with respect to the model. The arm must be completely extended each time a measurement is taken. The hand and the tool that is used to measure are held between the artist's eyes and the part of the model being measured. This procedure is absolutely necessary so the relationship between measurements is true.

The distance is measured from the top of the tool, where the eye sees the beginning of the subject to be measured, to the position of the finger that indicates where it ends. The two critical measurements are the total height and width of the composition, but one measurement must be established that by simple proportion provides all the remaining ones.

When a measurement is taken, the arm must be completely extended.

THE DIFFERENT GROUNDS AND THE PLAY OF LIGHT

An analysis that makes it easier to frame and take measurements consists of studying the various grounds that can be abstracted in the model and the play of light. There is a foreground, a middle ground, and a background.

An Error Results in Distortion

When taking measurements everything must be correctly related. Otherwise noticeable distortions in the representation can easily occur. Each distance that is transferred onto the paper must be checked to make sure that it continues to maintain the proper relationship to the rest. This general evaluation is easier to do if each object is related to the

Van Gogh, Study of a Tree. Charcoal pencil on light-colored paper with white chalk highlights. With the correct proportions, the tree trunks and the branches can be creatively drawn against the light to make them stand out in contrast to the luminous background.

The surface of the river can be created with the most appropriate texture to describe the foreground and to make it contrast and differentiate it from the middle ground, which is the subject. In this case the study of the proportions is very simple and can almost be carried out by drawing them by eye.

The Foreground, Light, and Reflections

The still life and the portrait are two artistic genres that fully exploit the foreground. In these subjects, the foreground corresponds to the closest parts of the model. They require the most intense highlights and areas of light. The background is the area behind the figure or the objects. The middle ground is established by developing the volumes, causing them to move farther away.

ground that had been previously identified in the model. The correct projection of the shadows can also serve as a checking point. Intuition should make the artist feel if something is not right, and careful observation will reveal what is wrong.

The measurements and proportions should be taken from the subject matter.

Drawing Proportions by Eye
The Different Grounds and the Play of Light
Temporary Conservation of the Work
91

The Background Is the Atmosphere

The most distant field is the one that corresponds to the background. Within the frame, all the space that "breathes" around the group of objects that are to be represented is very important. A proportion exists between the occupied space, as it were, and the empty space (or of the texture of another object that serves as a background, such as drapery, and that offers a contrast of texture or rhythm with the main objects). The mistakes in the proportions that are outlined in the background with great drama are easy to notice with the naked eye.

> **MORE INFORMATION**
> - Tonal Values **p. 80**
> - Chiaroscuro **p. 82**
> - Lines Highlight Contours **p. 84**
> - Receding Lines **p. 86**

The Drawing and Tonal Value

The proportions of the drawing must be carried through to the color and tone. Even when the drawing is proportionately correct, a false representation of the values of the color and tone can also cause distortions.

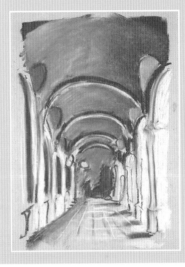

M. Braunstein. Blue and white chalk on very light blue paper. The various dimensions of the models are resolved through the analysis of their perspective, and in this case, by locating the single vanishing point.

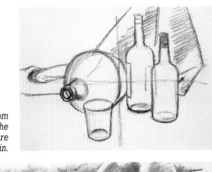

Working from a model, the shapes are blocked in.

The Middle Ground and the Play of Light

There can be more than one intermediate field, depending on the model. In a still life lighted from the side, it is advisable to identify the light that runs through the various objects located in different grounds, to respect the premise of "variation within order." The reach and surface occupied by the areas of light are as important as maintaining a correct relationship among the proportions of the forms. Therefore, observing an accurate representation of the tonal values also serves as a rule for checking the size in which the bodies are represented.

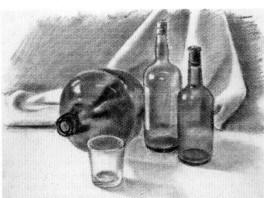

Jordi Segú gives volume to the forms by correctly applying the different charcoal tones.

TECHNIQUES AND PRACTICE

TEMPORARY CONSERVATION OF THE WORK

Whether you have a drawing that has been created over several sessions and it
needs to be kept half finished until the next session, or it is a completed project,
it is important to preserve the work in the best possible conditions. Since the dry
media are so fragile, it is very important to use a fixative.

On Using a Fixative

A word of caution regarding
the advantages and disadvan-
tages of using a fixative: The
conservation of a drawing that
has not been sprayed at all is
very difficult. But the artist
should not overuse the fixative
because it can stain, turning
the work dark and destroying
delicate contrasts in the
process. It is usually recom-
mended to spray the work with
a light overall coat. The fixa-
tive spray should be held at a
sensible distance, about 8
inches (20 cm) from the work,
and quickly sprayed on with a

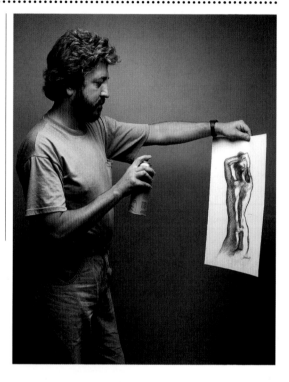

*The motion for applying the
spray should be quick,
continuous, and regular. It can
be circular or zigzag, making
sure that the entire surface
of the drawing is covered.*

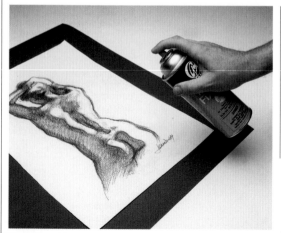

continuous circular or zigzag
motion. This operation must be
carried out in a well-ventilated
area so the toxic fumes can
dissipate without endangering
your health. Then the fixative
is left to dry thoroughly.

The Work Loses Pigment

Drawings that have been
done with dry media always

*If it is necessary to apply a
second coat, wait until the
first one is completely dry.*

The Different Grounds and the Play of Light
Temporary Conservation of the Work
Framing

93

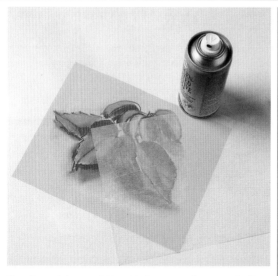

Once the work is sprayed, it must be kept properly protected with a sheet of paper. The protective paper should be transparent or translucent enough to be able recognize the drawing without having to remove the protective sheet unnecessarily.

The Protective Sheet

The protective sheet that is placed over the drawing done with charcoal, sanguine crayon, or chalk should be properly centered, laid directly over the work, and not moved once it has come in contact with the medium. Every time the drawing is uncovered, one of the corners of the protective paper must be held down while lifting the opposite one diagonally. This way you avoid rubbing the drawing against the protective sheet.

MORE INFORMATION

• More Materials **p. 46**
• Framing **p. 94**

lose some pigment, even the ones that have been protected with a fixative.

This is because the fixative should not be overused if you do not want to ruin the drawing, and also because it is impossible to avoid rubbing it against the protective sheet, especially when the drawings are being transported.

Special Protective Paper

Every work, finished or half finished, must be covered with a sheet of tracing or tissue paper, not only for its own conservation but also to avoid dirtying the back of another work that may come in direct contact with the drawing, even if it has been sprayed with fixative.

There are papers of different qualities that can be used to protect the drawing. It is advisable to use tracing or tissue paper that is quite transparent and somewhat satiny, so the powder from the charcoal, sanguine crayon, or chalk does not adhere to it.

The Portfolio

It is a good idea to have several different-sized portfolios available. This way the drawings do not move inside the folder when they are carried from place to place.

The portfolios that have zippers provide better protection from light and humidity. However, the most popular folders are the ones that have two pairs of strings to close them, and they are very practical to use as presentation portfolios.

Artists usually have several portfolios of different sizes to protect and transport their drawings.

FRAMING

A drawing that is stored in a portfolio, covered with its own protective sheet, is protected only temporarily. To provide long-lasting protection for a charcoal, sanguine crayon, or chalk drawing, it should be framed. There are several components that make up the frame, and each has a specific function.

Framing Dry Media

Framing a charcoal, sanguine crayon, or chalk drawing provides long lasting protection. However, in addition to the frame, a drawing done with a dry medium needs glass and a mat.

The mat is not only for aesthetic and decorative purposes, but also means, the glass never touches the drawing. This guarantees the proper conservation of the drawing because there is never any rubbing.

The Usual Problems

The worst enemy of a charcoal, sanguine crayon, or chalk drawing is humidity. This does not mean that only a flood can destroy this type of work, because even too much moisture in the air can end up ruining it. That is why museums all over the world strictly control the level of humidity in the rooms where they exhibit vulnerable works of art.

But falls or bumps are also damaging for drawings done with dry media. Despite the frame, the powder that is less adhered ends up coming off.

The frame for a charcoal, sanguine crayon, or chalk drawing includes the frame, the mat, the glass, the backing, and the staples or brads.

Therefore, it is best not to transport this type of work often.

The Frame Enhances the Work

The drawing is, without a doubt, the most important component. But it can be argued that a well-chosen frame enhances any work done with dry media. The frame has a series of different successive components: the spacer for the mat, the mat itself, the frame's spacer, if it has one, and the molding of the frame itself.

A Decorative Matter

The mat, so critical for good conservation, can also fulfill a

MORE INFORMATION
- The Chalks **p. 22**
- Volatility of the Medium **p. 54**
- Temporary Conservation of the Work **p. 92**

The glass (1) resting on the mat (2) leaves an air space between the glass and the drawing (3), while behind it, the backing (4) provides the final protection for the paper.

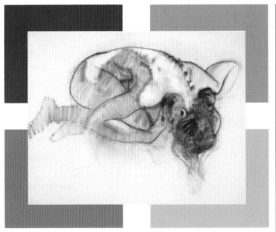

The colored mat that is most appropriate for the drawing can be chosen from a wide selection.

A Different Frame for Each Work

A baroque frame with a lot of molding and many flowery details does not have the same effect on the drawing as one that is functional and simple. The subject matter sometimes suggests the type of frame that it requires. But the artist's interpretation of the theme is, without a doubt, also a very important element when choosing the frame. The sensitivity and the desire for innovative solutions sometimes make the artist seek contrasting styles. Therefore, the work is not finished when a drawing is completed, but continues until the most attractive option for the permanent frame has been chosen.

decorative role if the chosen color enhances or contrasts with the dominant color of the drawing. There is a wide selection of mats available and they can be purchased with different textures. The mat, the edge of the mat (which can even be gold color), and the frame (which are available in different types of moldings and colors) work together to enhance the drawing. When you compare an unframed drawing with one that has been properly framed, you will see that this protection enhances the work in addition to adding value.

In a good framing shop, besides a wide selection of frames and mats of different textures, shapes, and colors, you will always find the valuable advice of a professional.

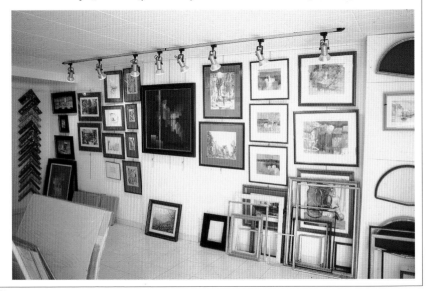

Original title of the book in Spanish: *Carbón, sanguina y cretas*
© Parramón Ediciones, S.A., 2003—World Rights
Published by Parramón Ediciones, S.A., Barcelona, Spain
Author: Parramón's Editorial Team
Illustrator: Parramón's Editorial Team

The publisher would like to thank the artists, museums, and
collectors who collaborated on this work.

All inquiries should be addressed to:
Barron's Educational Series, Inc.
250 Wireless Boulevard
Hauppauge, New York 11788
http://www.barronseduc.com

International Standard Book No.: 0-7641-5548-2

Library of Congress Catalog Card No.: 2002116478

Printed in Spain
9 8 7 6 5 4 3 2 1

Note: The titles that appear at the head of the odd-numbered
pages throughout the book correspond to:

Title of the previous chapter
Title of the present chapter
Title of the following chapter